The Art & Times of
DANIEL JOCZ

The Art & Times of
DANIEL JOCZ

foreword by Susan Grant Lewin

with essays by Wendy Steiner, Jeannine Falino, Patricia Harris, and David Lyon

edited by Sarah Davis

arnoldsche

CHERRY SOLITAIRE, necklace (p. 143)

Foreword

Susan Grant Lewin

I became enamored with the work of Daniel Jocz in 1996, when I was writing my first book on contemporary jewelry *One of a Kind: American Art Jewelry Today*. American jewelers were developing a strong voice, distinct from the European jewelry scene. I was a journalist at the time, serving as architecture editor of *House Beautiful*, and was persuaded by my friends Robert Ebendorf and Harry Dennis that the best way to demonstrate American jewelry's vitality was to publish a book.

Although I enjoyed collecting and wearing jewelry, I was relatively new to the field and did not know the full scope of jewelry in America. I formed an expert committee to guide my choices of who to include in the book. My team comprised jewelers Thomas Gentille and Pavel Opocensky, along with author and curator Suzanne Ramljak. In these days before the internet as we know it, we invited several hundred American jewelers to submit photographs of their work by mail and together we reviewed thousands of images. From this vast stack of images, the work of Daniel Jocz immediately caught our eye; his powerful and original polymer *Proto* rings (pp. 76–9) were so striking and fun that we put them on the back cover of the book.

When *One of a Kind* came out, Jocz's incredible gallerists, Libby and Jo Anne Cooper at Mobilia Gallery, invited all of the Boston jewelry scene. There were pot stickers and fabulous jewelry. The crowd was full of interesting artists, and afterwards we carried the party back to Jocz's house. That weekend I got an education on the vibrant Boston scene and especially on Jocz's work.

My interest grew with each new jewelry series. Jocz's work surprised me. I never knew what would come next. Unlike many artists whose work was unswerving and consistent, Jocz would freely follow his muse wherever it led him. I have observed his career grow and flourish in unexpected directions. I loved the fact that he carried small sheets of silver in his pocket when he was traveling. If he was charmed by a scene, he could quickly capture the moment in metal, as in his *Sketchbooks* series (pp. 96–103). There was a spontaneous quality to the work, yet it was always rich with meaning. I was smitten by the endless originality and inventiveness—from cherries to cigarette butts (pp. 138–43), food faces (pp. 104–5) to flocked fruit (pp. 167–8). No one else was doing anything like this. Not even close. Museums took notice, and I became one of his largest collectors.

Everything about Daniel Jocz is larger than life, his humor, his generosity, his appetites, and his work. His open spirit is fully embodied in the 2007 neckpiece series *American Riff on the Millstone Ruff* (pp. 168–81). Inspired by the extravagant scale of seventeenth-century Dutch ruffs at the Rijksmuseum in Amsterdam, he updated them with automobile paint at a Boston precision shop that detailed motorcycles. Pure bravado and Jocz at his best! It has been a pleasure to have a front-row seat to his creativity, and I am enthusiastically waiting to see his latest work.

A Touch with the Trickster Sublime: Daniel Jocz's Artistic Provocation

Wendy Steiner

Minutes from Daniel Jocz's home in Tyringham, Massachusetts, is a graveyard where a lone obelisk tapers twelve feet into the sky (p. 10). At the top is a bronze metronome. The obelisk marks the resting place of Fluxus collector Jean Brown, who died four years after Bay Area sculptor Joan Brown was crushed to death by a polychrome obelisk she was installing in a gallery in India. To my knowledge, there is no connection between the two Brown women or their obelisks. Framed by bare tree branches and the wooded rise of Tyringham Valley, the metronome silently, motionlessly, keeps time.

But this is to jump ahead. It is Covid summer, August 2020, a blur of stalled hopes and frayed patience. Jocz and I sit far enough apart on a bench in Madison Square Park to take our masks off. It is our first meeting. Jocz is known in the jewelry world as a "trickster," "provocateur," "change agent," and "wild card."[1] A hat he made for a gallery talk—a version of French proto-Dadist Alfred Jarry's chapeau in the famous bicycle photo—was rigged to drip water down his face when he started speaking (pp. 11, 148–9). His contribution to Helen Drutt's elegant *Challenging the Châtelaine* exhibition was a gadget belt for the everyman Joe Blow, with elastic bands and paper for spitballs (pp. 12, 146–7). "Is there within us, perhaps, a recognition," Jocz once queried, "that we would like to poke our finger in the eye of established institutions or authority just once?"[2]

Well, sure there is. But maybe not at this moment. We are in the midst of a pandemic, the unraveling of American democracy, racial violence in the streets, children in cages on the southern border, women's rights tottering on the brink. Old, white, bad-boy artists—give us a break!

Searching for common ground, a hook for the essay I may agree to write, I ask Jocz whether he has a position on feminism. "Not really," he replies, and as an afterthought, "I'm not against it." Second try: since his work is worn on the body, does he think about the interplay it sets off between art and flesh? "Not really," he repeats, but he is not against that either. I recall a magazine spread of him flanked by leggy models decked out in his jewelry ruffs. Is he interested in fashion? Bingo: third time is a charm. His cheeks pleat up in an ecstatic grin—think: Saint Theresa in a Sunbeam in Madison Square Park—and he's off.

Below: The Berkshires home and studio
of Daniel Jocz
Bottom: Obelisk grave marker,
Tyringham, MA

In high school he discovered *Harper's Bazaar* and has been hooked on fashion ever since. "Fashion is candy," he declares. "The only reason it's there is to make you want it, and as soon as you get it, to make you want more." Last fall, he went out to buy a shirt and came home with a whole new wardrobe. I have not really done that myself— well, once maybe—but I am not against it. I consider his almost childlike exuberance. It is sort of Dada, "an anarchy of the heart."[3] I am not against that either.

Jocz grins beatifically again as he speaks of the jazz club we passed on the way to the park. It reminds him of the concert long ago that made him an artist. He was in his final year of a sculpture degree at the Philadelphia College of Art and totally stumped for a thesis project. At the time, the mid-1960s, being an artist meant being a Pollock or a de Kooning—a hero defying tradition, conformity, fascism, or McCarthyism—a Philip Guston trying "to fashion plastic images strong enough to hold the terrifying and contradictory spirit of the age."[4] Critics were larger-than-life then, too, locked in mortal combat over cartoonish storylines for art: a Clement Greenberg cheering on the march toward ever "purer" abstraction; a Hilton Kramer defending Taste and the Aesthetic from left-wing, no-talent nihilists trying to pass off paint splatters as masterpieces. For a dyslexic son of Wisconsin farmers and shop workers, the first in his family to go to college never mind aspire to be an artist, it was hard to imagine entering such an arena. The artistic ferment of midcentury New York had formed Jocz, but it was now paralyzing him.

Stuck, he went out to Pep's, a hole-in-the-wall jazz club. John Coltrane was there, along with some friends. That is an understatement, Jocz makes clear: the stage was crammed with jazz greats. As the hours ticked by, they launched into Coltrane's infamous *Double Quartet*, each foursome on its own journey, riffing solos in a solid wall of sound. Jocz felt "the beauty of the total chaotic thing." I picture that Saint Theresa grin erupting as it dawned on him that he could do the same thing—*whatever he wanted*—regardless of what anyone else was doing. Permission granted.

Back at school, he gathered scraps of metal off the floor and started welding, bowerbird-style,[5] and after a few all-nighters he had his thesis project. And it won first prize. "It was the best thing I ever did," he confesses. That seems unlikely, given the half-century of achievements that followed. Maybe what was the best was feeling that freedom for the first time.

"Read *Ninth Street Women*," he suggests at the end of the interview; "It's all there." It occurs to me that Jocz may be more of a feminist than he lets on. Mary Gabriel's 2018 book focuses on five remarkable—and insufficiently celebrated— women painters who embodied the assumptions of AbEx New York every bit as fervently as their male counterparts. "In their art and their lives, the abstractionists rejected the consumer society arising out of the war in favor of the two elements lost in that war: truth and freedom."[6] With Pollock's example before them, Gabriel goes on, "Nothing less than ultimate freedom, ultimate risk accomplished on a large scale, would ever do again."[7]

On the train to Jocz's studio a few months later, it occurs to me that risk, truth, and freedom are increasingly rare commodities. It is not just Trumpism that is to blame.

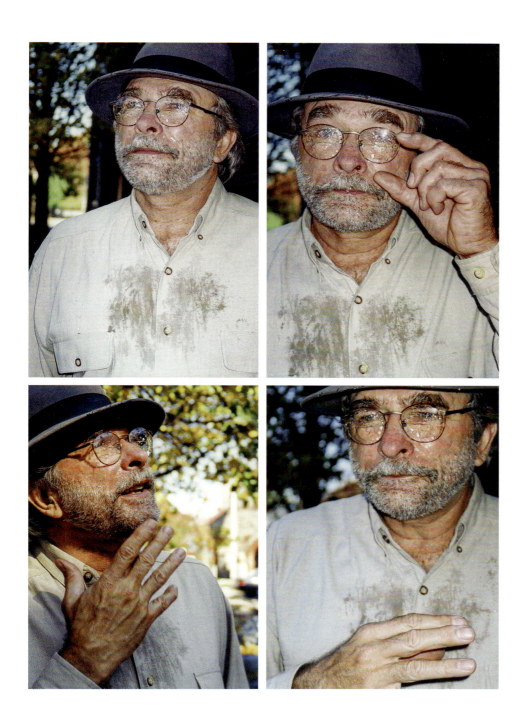

Daniel Jocz wearing *Rain Hat* (p. 149), 1988

The National Gallery in Washington, D.C., has just "postponed" (in effect, cancelled)[8] a Philip Guston retrospective for fear that his KKK figures would cause offense. It is not as if Guston had been extolling the Klan. His hooded gnomes are ringers for Alfred Jarry's Père Ubu in *Ubu Roi*, a play so anti-authoritarian and original that it inspired riots in Paris in 1896. When Guston's paintings were first shown in New York in the 1960s, they created a different sort of scandal, one that has taken the art world half a century to get over: the return of representation. And just when a major museum finally prepares to honor him, political correctness shuts it down.

But none of this agita disturbs the peace of Tyringham Valley. Jocz and his late wife, Katherine Bock, built their light-filled house in the Berkshires beside acres of towering pines and sugar maples. In the forest, a Zen brook spills down a ravine, zigzagging from stone to stone. Moss covers fallen tree trunks in a bright emerald flocking, and ferns poke out of the dry leaves, so precisely articulated that they look like Pop Art. It is not the setting one imagines for an artist provocateur.

Jocz's studio is a tower-like room facing the woods. Most of his work is stored in a few boxes under a worktable—rather like his new kayak, which folds down to suitcase size. Jocz likes miniaturization. It is what drew him to jewelry mak-

ing in the first place, he says, after his start as a sculptor. He would compress a huge idea into a tiny brooch and then stand back and watch it explode. I think of André Breton's "Beauty will be convulsive or it will not be at all,"[9] and Breton joins Coltrane, Jarry, Pollock, and Guston in that crowded studio. Standing above them all is a calmer figure—an engineer. Like his father, Jocz once worked on a shop floor, directing the design and production in an acrylic furniture factory. His early bracelets and necklaces are engineering marvels, their gold and silver insets intersecting in unforeseeable patterns as they meet around the curve of a wrist or throat (pp. 42–9).

Oddly enough, it was not metalsmithing that made Jocz famous, but flocking. His *Candy Wear* Xs and Os (pp. 158–9) caught on in the fashion world in the late 1990s: jewelry kisses and hugs in neon shades of fuzz—flip, chic, adorable. (Can't you just hear Greenberg—or Kramer—sputtering away about kitsch and commercialism?) But ask Jocz about flocking and you learn about electrostatic guns, monofilament fibers, and glue timings. To create his ruffs (pp. 168–81), he had to master aluminum sculpting techniques and motorcycle finishes. A fashionista dog carrier (p. 151) he is creating requires a dog mannequin for the final fitting. "Engineering" takes in a lot of ground for this artist.

And so does dreaming. "I need to wed the dream to the desire to make it palpable," Jocz declares in a booklet he designed for his 2011 show, *Series of Dreams*. Or rather, that is what his painter friend Robert Godfrey ventriloquizes him as saying in a "letter" in that booklet—though not in the voice of "Robert Godfrey." The letter writer is a bibulous Irish poet named "Elwood Beach" (after a sandy stretch of Australian coastline, pp. 202–3). In the booklet, Jocz calls Beach his "noir." The pair turn up again in the catalogue for Jocz's 2014 sculpture exhibition, *Like Garage Band*.

The booklet for *Series of Dreams* contains grainy close-ups of Marlene Dietrich, as well as images of jewelry made of pseudo lipstick-smeared cigarette butts. Joe Blow's châtelaine floats by a few pages later, along with the self-raining hat and some pink Xs and Os tattooed on an arm. The accompanying text chronicles six chance "dates" Jocz had with the bedroom-eyed Dietrich. The images "document" these noir encounters, like the photos of gloves and Parisian landmarks in André Breton's *Nadja*. As an erstwhile English professor, I note that Beach's alleged hometown of Quilty in County Clare, Ireland, sounds suspiciously like Clare Quilty in Nabokov's *Lolita*, who is Humbert Humbert's doppelgänger (and so, ultimately, Vladimir Vladimir's). You get the picture: superimposition, convolution, chiming. Three years later, "the beauty of the total chaotic thing" is reenacted in the booklet *Like Garage Band*.

But these playful provocations might never have come about. On 9/11 Jocz's surrealism slammed up against an unthinkable reality. "After that horrible and tragic day . . . creativity and art seemed ridiculous and reason seemed lost to me," Jocz wrote in his own voice, *de profundis*. Stricken, he went to teach at Haystack Mountain School of Crafts in Deer Isle, Maine, where his colleagues and students spent the whole session telling each other stories of their trauma. And just as in the Philadelphia jazz club decades before, this shared communication cut through Jocz's creative paralysis. Back home, a mental image of bleeding paper floated into his mind. He rendered it

EXPLO, wall panel (p. 201)

as a silver rectangle with handmade red glass beads, the first of six tablets/brooches/ billboards — his words, exploding in scale and communicative reach. These works constitute *American Requiem 3047.9.11.2001* (pp. 108–13), "a visual poem-prayer."

A brooch-sized catalogue accompanies the pieces, compressing the welter of ideas and influences that went into them. Quotations from Hector Berlioz's 1837 *Requiem: Grande Messe des Morts* fill several pages. This music, Jocz felt, traversed the very "journey" he had taken in his grief. The Mass anticipated both the terror of 9/11, "The trumpet scattering its awful sound / across the graves of all lands," and the beauty and empathy it would eventually inspire in him: "Eternal rest grant the dead, O Lord." Like a latter-day Edmund Burke, Jocz viewed this crossing of terror and beauty as an instance of the Sublime. He describes *American Requiem* as a gesture of sublime sharing, "a sacred prayer that all can embrace." The series is immensely moving, a masterpiece in the history of jewelry art.

In the absence of a term in traditional aesthetics for Jocz's interactive provocations, *trickster sublime* comes to mind. It is not a bad description of his approach to teaching either: "You throw out crazy ideas and they throw crazy ideas back at you. It [is] a fervor."[10] Jocz's jewelry pieces can be seen as engines designed to generate dialogue, sociability, and fervor. The Boston metal scene in its heyday, as he describes it, had that kind of excitement—thronged gallery openings, wild dance parties, all-night arguments. Jocz's face lights up at the memory, and especially at the checkered back-and-forth it brought him with the Boston artist Joe Wood.

That dialogue is second only to the one Jocz carries on with Jocz. The pair returned to sculpture in the 2010s, and serve as models, too, in a huge double self-portrait hanging in the studio in Tyringham (p. 8). For clarity, I shall refer to the human artist of the duo as "Dan Jocz" and to his fantasy emanation as "DJ" (in honor of his *Garage Band* chops). Dan Jocz appears in this self-portrait as an immediately recognizable outline in blue wire—the broad shoulders and arms framing the torso, hands thrust into trouser pockets. The wire Dan Jocz is attached to the much larger, messier, anarchistic DJ, an AbEx assemblage of roughly nailed boards, metal scraps, paint, and feathers.

The interchange between the two Joczes is perplexing, rather like Wittgenstein's rabbit and duck. Dan Jocz, though admirably finite and distinct, keeps fading into the unruly dreamwork of DJ. The lower body of the wire outline, to be frank, is less compelling than DJ's blood-red cartoon privates and the scene of passion sketched nearby, and DJ's wavy halo of red beads is more attractive than the blue wire head below it—which in any case is barely visible against DJ's hot-pink paint scribble. Like Saint Anthony, DJ's side is transfixed by sharp missiles: pointed cones of scrap silver. They pose another rabbit/duck perplexity—on the one hand, serving as funnels allowing reality to pour into DJ and, on the other, as megaphones for him to broadcast his feelings out in the two-way messaging of the trickster sublime.

The two Joczes have settled their differences by the time we set off for the train station. We make a stop at the Tyringham graveyard, where the obelisk-cum-metronome stands outlined against the pale October sky, its inscription barely visible. All the way home it haunts me. The next day I Google "Jean Brown," but by mistake type in "Joan Brown," and suddenly I hear the chiming of Brown and Brown and obelisk and obelisk, *Like Garage Band*.

I would offer this conclusion. Though I was not there that night in the Philadelphia club when John Coltrane and his friends blew the roof off, I have witnessed the explosion of possibility they set off in Daniel Jocz. He passes it on to us through his art and smiles his beatific grin at our bemusement. And so, even without hearing the beautiful chaos that launched him as an artist, I would be willing to bet one thing: the musicians that night never lost the beat. They knew what they were doing, letting loose that way, risking everything: they were keeping time. The freedom they felt, they felt together, and they egged each other on to feel it more, each in his special way. That is what artists like Jocz can do. And it can be sublime.

SELF-PORTRAIT, 2020 (detail p. 8)
Found materials, spray paint, plywood

1 Patricia Harris and David Lyon, "Boston Metal, Making the Scene," (this publication) p. 27.
2 Daniel Jocz, *Series of Dreams* (Hudson, NY: Ornamentum Gallery, 2011), n.p.
3 Ibid.
4 Mary Gabriel, *Ninth Street Women* (Boston: Back Bay Books, 2018), p. 200.
5 Robert Godfrey, alias Elwood Beach, makes this comparison in *Series of Dreams*.
6 Gabriel, p. 272.
7 Gabriel, p. 208.
8 Jason Farago, "Museums Fail to Meet A Moment," *New York Times* 10/01/20: C1. Under international pressure from artists, the retrospective was scheduled for 2022: Julia Jacobs, "After a Backlash, a Philip Guston Retrospective Will Open in 2022," *New York Times* 10/29/20: C5.
9 André Breton, *Nadja*, 1928.
10 Libby Cooper, his dealer at Mobilia Gallery, says he was "terribly influential as a teacher" and "adored by his students," Op. cit. 1.

STICKS, necklace (p. 42)

Boston Metals: Making the Scene

Patricia Harris
and David Lyon

Sometimes timing is everything. Daniel Jocz knew nothing about the Boston art scene — or even if there was one — when he hitchhiked across the country from Oakland, California in the mid-1970s. The young sculptor had just finished a stint working for a Bay Area foundry. His transcontinental drift landed him in Boston to meet up with friends. He had no idea that he was about to be part of something big.

Unless you have the power and resources of Lorenzo Medici, it is impossible to will an artistic renaissance into being. The process is far more random. Art scenes flourish in the wake of fortuitous convergences of talent on fertile soil. In the mid-1970s, Boston was poised for a creative breakout. The city was hardly alone. Thanks in part to the increasing presence of artists in professional academic programs, American culture was realigning how studio crafts were regarded. The emergence of the concept of "art in craft media" led to a blurring of the old (and arguably artificial) lines between craft and art.

Jocz was attuned to the evolving zeitgeist. Although still working in sculpture, he had made his first forays into jewelry. He reached a turning point in 1977 — a kind of prolonged "aha!" moment — when he began working with Boston jeweler Joan Carriere. He discovered that jewelry could expand the ideas he had been exploring in large-scale metal sculpture. "She convinced me that I could work out my ideas in miniature,"[1] he recalls.

He was not the only one thinking that way. In the absence of a guild system that had ruled crafts from medieval times to the eighteenth century, artisans — including metalsmiths — began clamoring for equal status with fine arts. The formation of the Society of North American Goldsmiths (SNAG) in 1969 was the first step toward the recognition of "designer craftsmen in the metal arts field," as the charter noted. Beginning in 1973, a sequence of SNAG journals led to the creation of the influential magazine *Metalsmith* in 1980.

An elevated regard for metalsmithing was a natural fit in Boston, where the tradition stretched back past Paul Revere. In his own time, Revere was as well-known as a silversmith and foundry operator as he was as a patriot and rabble-rouser. In the century after the American Revolution, Boston's moneyed class had the taste and

[1] Except where noted in the text, all quotations come from interviews conducted between 2019 and 2021.

wherewithal to patronize artisans in the building trades as well as the decorative arts. In 1873 Massachusetts established the first publicly funded art school in the United States. Its stated goal was to train public school art teachers and to prepare artists, artisans, and designers for local industry. Today it is the Massachusetts College of Art & Design—MassArt for short. In 1876, shortly after the Museum of Fine Arts, Boston (MFA) was founded, it created the School of Drawing and Painting that eventually evolved into the School of the Museum of Fine Arts, Tufts, colloquially known as the Museum School.

New England was the American beachhead for the Arts and Crafts movement, influenced by William Morris's belief that all household objects should be beautiful as well as useful. The Society of Arts and Crafts (SAC) was founded in Boston in 1897 "to develop and encourage higher standards in the handicrafts," lending a dignity and sense of artful purpose to what had been considered "mere" decorative arts to that point. Like MassArt, SAC trained many artists who would work in factory settings, but it also marked the beginning of studio craft as a profession rather than a skilled trade.

Emily Stoehrer, the Rita J. Kaplan and Susan B. Kaplan Curator of Jewelry at the Boston Museum of Fine Arts, holds that Boston was the epicenter of the Arts and Crafts movement in the United States. She finds parallels between then and now. "There were all these educational programs popping up, and people were going to them and learning with well-known teachers and following in their footsteps," she says. "In a lot of ways that tradition continues—when metalsmiths go to prestigious institutions, earn their bachelor's and master's degrees, and, to varying success, go out to make a career."

The MFA represents both periods. It owns a rich collection of Arts and Crafts jewelry and pottery produced in the Boston area. But Stoehrer points out that contemporary studio jewelry is also one of the strengths of the collection. A selection is always on display in the Daphne and Peter Farago Gallery in the American Wing (including Jocz's *American Requiem 3047.9.11.2001*, pp. 108–13). "American" might be the key word. Even today, she says, "In Europe you still see more traditional materials than you do in the United States, where anything goes in terms of what jewelry is made of. I think there's a lot of excitement about what has come out in jewelry in the last twenty years."

Longer, perhaps, than twenty years. From 1985 to 2015, the contemporary jewelry scene flourished with around two dozen working artists. This is the story of a generation of sweeping artistic achievement in Boston and some of the people who made it happen.

THE ACADEMIC FOUNDATION

As the baby-boom generation came of age, it triggered a tectonic shift in American culture. A college education came to be seen as the norm, at least among the middle class. High-school graduates who, in another time, might have gone directly into the workforce or vocational training, instead matriculated at the nation's colleges and universities —which, in turn, expanded to meet demand.

In a sea change of cultural attitudes from their practical parents, many of these students arrived on campuses with a hunger for self-expression. Colleges and universities were only too glad to accommodate them, transforming scattered hands-on art classes into full-blown curricula granting undergraduate and graduate fine arts degrees. Higher education replaced the atelier as the training ground for new talent. A generation of graduates armed with an intellectual framework for their creativity and professionalism, attested by their prestigious diplomas, set out to forge careers as independent artists. Jewelers were certainly no exception.

The proliferation of academic programs provided many of these graduates with supplemental or even primary employment. Those who could make a name for themselves as artists and simultaneously develop their pedagogy found an economic safe harbor as faculty. Others turned to part-time teaching, often in non-degree extension programs, to keep one foot in the academic world. The academy became the patron for a new age.

In addition to MassArt and the Museum School, Boston University further burnished the higher education bona fides of studio craft when it established the Program in Artisanry (PIA) in 1975. During its decade in Boston, PIA brought a core faculty of master artists in craft media who worked closely with a small cadre of students. Metalsmith Vincent Ferrini was among the founding faculty and was succeeded by J. Fred Woell, Patricia Daunis (now Patricia Daunis-Dunning), and Jamie Bennett.

In 1985, Boston University discontinued support for the PIA, which became part of the Swain School of Design in New Bedford, Massachusetts, and is now part of University of Massachusetts Dartmouth. PIA faculty and graduates had been driving forces in furniture, metals, fiber, and ceramics in Boston; their physical departure left a vacuum quickly filled by MassArt. By the time PIA left, Jill Slosburg (now Jill Slosburg-Ackerman) had been teaching at MassArt for a decade after earning her BFA from the Museum School. Although Joe Wood was the only full-time metals faculty member until Heather White was hired from the University of Akron in 2000, other artists began teaching classes at MassArt in the 1980s. Dan Jocz was among the mix of adjunct faculty and continuing education instructors.

Slosburg-Ackerman recalls a close-knit, if freewheeling, community. "We did a lot together for a long time," she says. One episode sticks in her mind. "I remember we all drove to SUNY [State University of New York] New Paltz to hear Hermann Jünger speak," she says of the pioneering German goldsmith. "He had a fresh perspective we had not seen in this country. It was incredibly stimulating."

The outsider perspective was Jocz's specialty. More than a teacher, he was a presence who brought the freshness of a studio artist unencumbered by committee assignments and the administrative paraphernalia of academe. Heather White recalls that Jocz "was the part-time person that we really wanted in the mix." Since he didn't attend faculty meetings, the school would schedule his evening classes for days when the rest of the metals faculty were teaching afternoon classes. They would stay late, Jocz would come in early, and many a late Tuesday afternoon developed into a lively discussion of art and ideas.

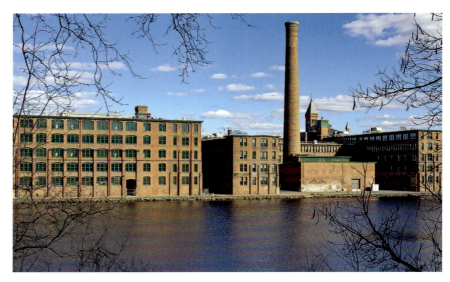

Above: Metalsmiths Joe Wood, Charles Crowley, and Claire Sanford with Allie at Top Dog Studio
Right: Waltham Watch Factory, home of Top Dog Studio

AD HOC SALONS

As artists finishing academic programs sought to establish studios in the Boston vicinity, they looked to old industrial buildings for low-cost raw space, creating artistic incubators by accident. Working side by side naturally turned to conversations about art and to parties that led to deep and enduring friendships.

After metalsmith Charles Crowley graduated from PIA in 1984, he discovered the Waltham Watch Factory twelve miles west of Boston on the Charles River. Crowley had already proven himself as an innovator of hollowware forms in silver and pewter by shaping his vessels with milling machines and lathes rather than the conventional stake-and-hammer technique. Needing a larger studio space than a bench jeweler might, he secured a portion of the central tower of the factory. Waltham Watch Company had discontinued production at the site in the 1950s, and the building was subdivided for light manufacturing. By the 1980s, some portions still contained abandoned equipment and parts, including cast-offs from the watch company. It was a perfect environment for metal artists, some of whom were happy to dumpster-dive to salvage interesting objects.

Crowley initially shared his studio space with Stephen Hyer, a high-end bench jeweler, and Duncan Miller, a gearhead engineer who worked with John "JB" Borchard to make portable carat scales for gemstones. Joe Wood and Becky Brannon, who had recently arrived together from Kent State art programs, soon shared the space as well. Crowley dubbed the arrangement Top Dog Studio, after his mixed-breed puppy named Allie. Claire Sanford, who earned a BFA from the California College of Arts & Crafts and an MFA at PIA, also moved in when a slot opened.

"Charlie signed the lease, cleaned, and created a really great working space," says Sanford. "The deal was that everyone paid part of the rent, part of the utilities, and threw the ball for the dog."

In many ways, Top Dog was the crucible in which a Boston metals sensibility was forged, but other studios were spread through the sprawling industrial space. Deborah Krupenia, now known as a master of mixed metals, returned to the Boston area in 1984 after earning an MFA at Southern Illinois University. She initially shared bench space in a studio with Rob Butler, a London-trained silversmith who would become known for his vivacious animal castings in the tradition of classical British silver.

"At one point there were an amazing number of metals people in the watch factory," Krupenia says. Unsurprisingly, they interacted a great deal. She remembers one of the Top Dog founding crew as a key resource. "Steve Hyer was a brilliant technician and very generous with his time," she says. "If you had a technical problem, you could always talk to him."

But much of the interaction was more informal. As could be expected of a concentration of young talent in close proximity, there was always an excuse to celebrate. "We had a lot of parties there — lots of eating and drinking, barbecues in the parking lot. We had a lot of fun," Claire Sanford recalls.

Still, art was never far from everyone's minds. At one point in 1986–87, the Top Dog studio mates hosted a party and invited metalsmiths from the building and surrounding area. Everyone was to bring five to ten slides of recent work. The concept, Becky Brannon recalls, was not all that complicated: "We'll just sit around drinking and talking and getting to know each other."

Krupenia recalls that she first met Jocz at such a gathering. "To have the chance to socialize was huge," she says. But she had no idea at the time that the interaction of the Boston metals community would have such long-lasting impact. "If I had gone back to the West Coast," she says. "I would have worked with the same alloys, but my work would have been more decorative. It comes out of the talks and the directions Dan was taking. He was influential without intending to be."

A critical mass of talent converging on the same spot effectively created an explosion of ideas. "When you have a place with a lot of people, you pull in all the threads from a lot of different places," Sanford observes. Ideas flowed as freely as the beer and wine. "People who have made a go of it seem to be part of a network. There was a lot of generosity, sharing ideas, talking about stuff." The Waltham scene lasted only until the early 1990s, but it caught the attention of the art world establishment. Groups from the MFA Boston and from the deCordova Museum in Lincoln would come through Top Dog on field trips, "sort of like seeing animals in the zoo," Sanford says with a laugh.

While the young artists at Top Dog were exploring new ideas, they valued connections to important metalsmiths that came before. Margaret Craver took particular interest in the group, with Deborah Krupenia keeping her in the loop on what everyone was experimenting with. Craver was an important metalsmith, innovator and educator who organized metalsmithing workshops as therapy for wounded World War II veterans in the 1950s. She also created summer workshops, manuals, and videos. She was delighted to hear what the young Boston makers were doing and her interest lent legitimacy to the artists.

The Boston jewelry scene dinner parties (metalsmiths unless otherwise noted):
Left: Joe Wood and Rebecca Brannon
Right: Rebecca Brannon, Joe Wood, Margaret Craver, Daniel Jocz, and Deborah Krupenia
Opposite: Robert Blouin (poet), France Roy, Katherine Bock Jocz (writer), Joe Wood, and Rebecca Brannon

Around the same time that Top Dog was winding down, a similar ad hoc salon was playing out in Cambridge. Sandra Enterline, who had studied metalsmithing at the Rhode Island School of Design (RISD), came to Boston in 1990 while her husband was studying in the landscape architecture program at Harvard's Graduate School of Design. She and Dan Jocz split teaching duties at the Museum School and hit it off immediately.

"We started having presentations at my loft on Harris Street in Cambridge," Enterline recalls. "People would have drinks and show their slides. It was a really nice networking thing." But unlike some sharing showcases, she says, "There was none of this pettiness and egos. If you made a shitty piece you were going to get told. But that's what you needed: 'Give me some feedback.'" Enterline returned to the Bay Area in 1992 and now gives guest lectures at the Academy of Art University and the California College of the Arts. But that sojourn in Cambridge remains stamped on her psyche. "I just never felt such a connectedness," she says.

The social bonds proved enduring and ultimately shaped the Boston metals scene for decades to come. When Crowley and Sanford wed and moved out of the Waltham building in 1992, taking the Top Dog name with them, MassArt was positioned to become the metal arts nexus.

BREAKING OUT

The Boston metals scene coalesced during a period of nationwide cultural ferment. During the 1970s, the National Endowment for the Arts revolutionized arts patronage in the U.S. with a budget that swelled to $114 million by 1977. Among the state-level agencies around the country, the Massachusetts Council on the Arts and Humanities (now the Massachusetts Cultural Council) was one of the best funded and most pro-active. The Mass Council-supported Artists Foundation administered fellowships that provided critical financial support and key recognition to artists working in fine art and in art in craft media.

In 1990, the Artists Foundation also hosted *Jewelries/Epiphanies*, a seminal exhibition on the evolution of jewelry from commercial ornament to full-blown art. The exhibition was curated by Catherine Mayes of the Artists Foundation and guest-curated by Joe Wood and Dan Jocz, who had first floated the idea with the foundation.

"The works in this exhibition are to be considered portable works of art which can be worn on the person or possessed purely as objects to be appreciated for their resonant qualities," Wood and Jocz wrote collectively in the curatorial statement. Seventeen artists from New York and New England participated in the exhibition and several were involved in an accompanying forum. It represented a triumph in the quest to place jewelry on an equal footing with other visual arts. Not coincidentally, it was also fun.

Jill Slosburg-Ackerman, one of the participants chosen for the show, remembers it fondly. "I think that show was really important for the development of the Boston metals scene," she says, noting that it was significant that the exhibition was held at the Artists Foundation at CityPlace, just off Boston Common.

Although Wood, Jocz, and Slosburg-Ackerman were all teaching at MassArt, "It was not really a MassArt show," she says. "It was a show designed to build community in the city." Ultimately, *Jewelries/Epiphanies* traveled to the Museum of Decorative Arts in Prague. It was one of the early connections between the Boston-area metalsmiths and those in Europe.

While *Jewelries/Epiphanies* was a one-off exhibition, a burgeoning gallery scene was beginning to provide sustained exposure for local metalsmiths. With an unlikely location in the Mall at Chestnut Hill in suburban Newton, Quadrum Gallery expanded its original focus on painting and graphic art to embrace art jewelry in the mid-1980s. Founder Cynthia Kagan brought in metalsmith Claire Sanford to provide a professional perspective. She in turn hired enamelist Becky Brannon, a connection made at Top Dog Studios.

A handful of galleries in Boston's Back Bay also offered visibility. Sanford notes that "the Society of Arts and Crafts was good at showing work by students and emerg-

Left: Jo Anne Cooper in front of Mobilia Gallery, Libby Cooper can be seen through the glass. Right: Arline Fisch speaking to Deborah Krupenia and Munya Avigail Upin.

ing artists." Brannon recalls that by the mid-1980s, "Body Sculpture was the top gallery. It carried a lot of dignified art jewelry, more gallery than store."

Cambridge-based Mobilia Gallery proved to be the game-changer for the metals scene. Sisters Libby and Jo Anne Cooper founded the gallery in 1978. In its early years, the Coopers focused heavily on fiber arts, especially wearables. When the gallery moved to a larger space in 1988, the Coopers began to shift emphasis from fiber to jewelry. Early shows included work by Colette, Earl Pardon, and Joyce Scott. Mobilia was among the first galleries to carry extensive collections from Wood and Jocz and to represent some of the other jewelers in the Boston scene. The Coopers deliberately cultivated local artists, even as they developed a corps of gallery-goers, art lovers, and collectors.

With its own invitational themed exhibitions, an ambitious program of openings and discussions with artists, and often exclusive or near-exclusive representation of major figures, Mobilia became an important nexus for the art jewelry world. Their themed exhibitions were especially critical for Boston metalsmiths.

"Their thematic exhibitions were very inclusive," says Deborah Krupenia. "They were wide open, and we could submit work to them."

That open door was deliberate. "Because of the schools, Boston is a hub of metalsmithing," explains Jo Anne Cooper. "It has a strong identity. We deliberately wanted to help nurture the jewelry scene."

Libby Cooper concurs, "We wanted people to learn about the art and the artists, and why the work is so special," she recalls. "It was all very symbiotic."

The Coopers proselytized on behalf of contemporary studio jewelry, taking risks to present work where art sometimes trumped commercial appeal. Wood recalls, "There certainly were not very many showcases for what I would consider to be the most interesting work. They relied on their collectors, other artists, and their own intuitive sense to show the most idiosyncratic work. That really made Mobilia an interesting place to go."

As tastemakers, the Coopers also played a key role in critical thinking about contemporary jewelry, helping to shape the collecting market as a result. "Libby from Mobilia was the person who really turned me onto what was happening in Boston," recalls author and collector Susan Grant Lewin. "Mobilia was a big factor in promoting Boston jewelry. They discovered who the collectors were and tried to alert them to what was going on."

Chief among those collectors was the late Daphne Farago, who ultimately donated key elements of her collection of modern and contemporary jewelry to several institutions, including the MFA Boston. When Lewin's definitive survey, *One of a Kind: American Art Jewelry Today*, was published by Harry N. Abrams in 1994, Farago "wanted to buy everything in the book," Lewin jokes. "Libby gave me a big party at the gallery — an absolutely fantastic party in honor of the publication of my book."

The Coopers have always had a knack for throwing a party, combining food and drink with a heady mix of artists, collectors, critics, and the gallery's habitués. Sometimes the conversations led to sales, sometimes to new creative directions.

"I remember one great conversation with Dan at an Arline Fisch show," says Joe Wood. "People were doing idea-based work and the show included her anodized aluminum flowers." As they talked, a mental switch flipped. "We thought this is ornament and will resonate with people at a subconscious level," Wood recalls. "Dan started working on flocking. I went from burned oil on metal to bright enamel. We both wanted to make something visually compelling. It fit with Mobilia's sensibility."

The Boston metals scene was gathering momentum. By the turn of the millennium, studio crafts, especially jewelry, had become more firmly than ever incorporated into the tent of fine arts. The Fuller Museum of Art in Brockton, Massachusetts, which had been founded in 1969 as a fine arts museum, was open to art in craft media from its outset. Ultimately, studio crafts subsumed the rest of the museum collection, and in 2004 the board of directors explicitly shifted the museum's focus to contemporary work in wood, fiber, ceramics, glass, and metals and changed the name to The Fuller Craft Museum. In a parallel shift in the recognition of studio craft as fine art by larger institutions, in 2006 the MFA Boston became the first major American museum to have a full-time jewelry curator, naming Emily Stoehrer the Rita J. Kaplan and Susan B. Kaplan curator of jewelry.

PUTTING BOSTON ON THE MAP

By the mid-1990s, the Boston metals scene had its own lively, if relatively insular, interchange of ideas about art, artistry, and technique. Some leading metals educators wanted to add more voices. Beginning in 1994, Wood, who served two separate four-year terms as department chair of Fine Arts 3D at MassArt, coordinated an ambitious series of academic symposia on issues in the metals world.

Social media had yet to link the world with instant communication. "Gatherings were our social media at the time, and holding a symposium with provocative speakers brought large numbers of interesting people together," Wood recalls. He surmised

that Boston was a good location for such a series, given its own resident art community, its proximity to Providence and RISD, to Maine, and even to New York. Reasoning that it is hard to build connections outside of academic circles, Wood aimed to bring together jewelry lovers, professional artists, and academics. "My thinking was that we needed to have social time before the event where we gave people food and coffee, and they could have about forty-five minutes to just bump into each other. Then we would commence the program. Of course, we had a lunch thing too."

Featured speakers came from across the country and around the world. In 1994, design theorist Clive Dilnot kicked off the initial symposium, "Art Jewelry: Questions of Context." Fresh from curating a show provocatively titled *What, If Anything, Is an Object?* at the Fogg Museum at Harvard, Dilnot moved the goalposts of conventional assumptions about jewelry as he built a new intellectual framework for regarding the discipline.

"Clive Dilnot gave the best talk about jewelry that I ever heard in my whole life," recalls Slosburg-Ackerman. "He talked about how jewelry can be everything. It can be sentimental; it can be theater . . . it just went on and on, and the way he spoke about it was deeply moving."

Moreover, people in the metals field began to pay attention to MassArt. In 1997, Wood followed up the initial symposium with "Legacies," honoring living metal artists who were already historically significant. The 2001 symposium addressed "The Ring" as jewelry object past, present, and future.

With "ContacT" in June 2004, "Connections" the following September, and "Parallax" in October 2007, the symposia series expanded beyond single days of presentations to multi-day conferences that attracted faculty and students from art schools across North America and Europe. As Wood recalls, the conferences "created the sense that Boston was a place where art is thought about and talked about."

The symposia made for some lively times as the worldwide tribe of art jewelers assembled to theorize and argue about the limits of art and life. To keep the discussion going, Mobilia Gallery—which helped sponsor the symposia—mounted exhibitions that complemented and expanded the topics. After the daytime academic sessions, everyone piled into buses to cross the Charles River to the gallery. "They'd have their food and it would be a big, crowded place," Wood recalls. "And they would have the work from the artists in the symposium. Students who could never afford the jewelry were opening the drawers and looking into all this stuff and eating all the food and it was good fun."

Libby Cooper concurs. "The symposia helped unify local artists," she says. "Yet people came from all over the world."

Nor was Mobilia the only party venue. Jocz had two apartments, one a studio in Cambridge that often became the venue for after-parties. On at least one occasion, he fired up his grill and made hamburgers for anyone who wanted one. That most American of activities so impressed a group of Estonian students that Jocz became known, at least in one corner of the Baltics, as the "Hamburger Man."

THE PROVOCATEUR

But Jocz was more than the grill cook. Every artistic tradition needs an innovator to come along every generation or so to keep the art form fresh and relevant. As the trickster figure of the Boston metals scene, Jocz was that generational change agent. He was the wild card. Everything and everyone he touched was changed. Complacency and accepted wisdom went out the window.

His personal touchstone was the New York art scene of the 1950s and 1960s, as Abstract Expressionism mutated into a myriad of post-modern forms. He was shaped by his undergraduate days at the Philadelphia College of Art (now University of the Arts), in Pennsylvania, where he could haunt the jazz clubs or theorize the night away in conversation at McGlinchey's, a classic dive bar near the college. As a budding artist, he was formed by the colloquy of passionate, like-minded souls. He would seek out that rush of ideas—or seek to generate it—again and again throughout his career.

"Cultivating different ideas—that's what Dan is about," says Wood, who often asked Jocz to join other MassArt faculty at student review boards. Jocz frequently provided perspectives from far outside the academic box. Sometimes it was like being doused with a bucket of ice water. "Dan's feedback was always the feedback that pushed me further," says Katherine Ingraham, who took several classes from Jocz and worked as his studio assistant.

Even observers outside of the education system saw Jocz's effect on young artists. "Dan was terribly influential as a teacher," says Libby Cooper. "His students adored him. He taught them that for every choice, there are many possibilities."

It is easy to believe that Jocz got as good as he gave. "MassArt students are hungry and talented," he reflects. "It was a joy teaching them. You throw out crazy ideas and they throw crazy ideas back at you. It was a fervor."

Such give and take was a throwback to his love of improvisational jazz. The repartee at its best encapsulated the cacophony and pure spirit of Pharoah Sanders and John Coltrane trading ever-more abstract saxophone lines as the quartet's pianist and percussionist fought to keep them anchored to the earth. Jocz always hungered for that kind of interaction with other artists—in academia, at symposia, at parties, or over a meal. Indeed, Jocz has a well-deserved reputation for his carefully crafted meals, including a legendary chili, and background soundtracks attuned to the company he kept.

"Dan is a creative force, always expanding the notion of fine jewelry," explains Jo Anne Cooper. Noting that he rarely did the expected, she says that "he was a mover and a shaker. His message was always to discover yourself and your passions and follow them."

Talk about marching to a different drummer. Jocz had been following that jazz percussion in his head—Elvin Jones, Rashied Ali—for more than a half century, putting him a measure ahead. "I was provocative because I couldn't help myself," Jocz says of his work, though he could as easily be speaking of his role in the jewelry world. "My muse told me what to do, and I'm not going to question that muse—ever."

He pauses and reflects.

"I was always very serious about all my fooling around."

Ring from *Zuc* series of 13 rings (p. 73)

"I Never Refused a Muse": The Art of Daniel Jocz

Jeannine Falino

Daniel Jocz's search for expression has taken him from small brooches to large wall sculptures, from metal to polymer clays, and from Minimalism to Expressionism. He makes surprising leaps from one series to the next, but a protean energy unites everything, and his pieces possess a monumentality despite the intimate scale of his work. Jocz said, "I tend to stuff big ideas into small packages, and then the jewelry almost seems as if it's bursting out. Many people think my pieces are much bigger than they really are, when they see a picture of them."[1]

Both playful and sensuous, Jocz's jewelry and wall pieces are characterized by bright colors, graphic qualities, and delicate surfaces. He sees his work interacting with the viewer as sculpture in motion on the figure, and he takes his craftsmanship as seriously as his artistic vision. His work defies neat categorization, but there are ideas that surface repeatedly, drawing seemingly disparate work together. All his work has an autobiographical aspect, with clever and subtle visual jokes that are entirely Jocz. He has outrageous, oversized flocked pieces and necklaces composed of cherries and cigarettes. Solemnity and grief are also found in his toolbox. The *American Requiem 3047.9.11.2001* series, created in memory of the 9/11 attack on the Twin Towers, is a meditation on life and loss.

Outsider status has energized his career. While pursuing a degree in sculpture, he identified the same artistic potential on a smaller scale in jewelry. He plunged headlong into this new field, learning as he went. Having an easy facility with tools, he adapted implements and appliances from other disciplines to meet his needs. Jocz said, "In some ways I am an outsider, never having a formal metals class, understanding the medium through many years of trial and error and talking with other people. It's true that I'm not really connected in the academic sense to the crafts world . . . I [am a] studio artist."[2]

Visually and musically, Jocz is an omnivore, seeking inspiration all around him. He described his approach simply, and with a grin: "I never refused a muse."[3] The house he designed in the Berkshires holds his studio and is filled with art objects by friends and artists he admires. The shelves overflow with books on poetry, art, and fiction by writers that he often refers to, including Italo Calvino, whose prose poem "Invisible Cities" (1972) is a rumination on the concepts of memory, place, and the pas-

sage of time. It is easy to apply Calvino's ideas to Jocz's oeuvre by thinking of his work as "cities." Calvino wrote, "Cities, like dreams, are made of desires and fears, even if the thread of their discourse is secret, their rules are absurd, their perspectives deceitful, and everything conceals something else."

ART EDUCATION:
"John Coltrane's music made me an artist."

Jocz was born in Beloit, Wisconsin, in 1943, the son of a machinist father and a mother descended from a long line of farmers. He recalls a happy childhood spent drawing cartoons and exploring creative activities with his sister. His student years were hindered by undiagnosed dyslexia. Jocz compensated with a humorous demeanor and the occasional bit of tomfoolery. An insightful teacher suggested that he might find a career in the arts. This was a revelation: Jocz had no idea this could be a career.

Jocz studied sculpture at the Philadelphia College of Art (PCA).[4] The lively ferment of ideas that he encountered exerted a massive influence on his career. Soon after arriving in 1962, Jocz seized every chance to learn about exciting ideas from creative people. He heard sculptor David Smith speak, attended Happenings by Swiss artist Dieter Roth (1930–1998), and dropped in on many art events. Jocz went to Manhattan to visit museums and stop in watering holes like La Figaro Café, one of the Beat Generation's leading hangouts, where he would meet with David Hare (1917–1992), a surrealist and visiting professor at PCA.

Several teachers in the PCA sculpture department were abstract artists, including Pop artist Peter Agostini (1913–1993), bronze sculptor George Spaventa (1918–1978), and sculptor Philip Pavia (1911–2005). A mimeographed copy of an essay called "Club Without Walls" circulating in the studio caught Jocz's attention.[5] (He found out later it was by Pavia.) It chronicled the New York Abstract Expressionist scene in the 1940s and 1950s. It struck Jocz that the vital scene of artists and an explosion of ideas he encountered became the crucible in which his artistic direction was formed.

Jocz had worked with sculpture and metal in Wisconsin, and he settled into the department easily, welding rods, brazing joints, and generally having fun. When studio work made him feel confined or frustrated, he headed out to the venerable McGlinchey's Bar "to get an education on being an artist."

Playing around in the iron shop, Jocz made cuff bracelets out of brazed brass on steel. When jewelry and metalsmithing professor Olaf Skoogfors (1930–1975) saw the work, he suggested Jocz take them to Wesley Emmons (1928–2011), another professor, who also had a jewelry store and could gold plate it. Emmons asked for one bracelet in return. The exchange was illuminating when Jocz realized that Emmons was charging thirty dollars for the plated bracelet that he sold for five dollars.

Senior year arrived at PCA, and Jocz had nothing for his thesis. He said, "Hearing John Coltrane's music at Pep's jazz club in downtown Philadelphia made me an artist. They started playing and it was chaos, total chaos for forty-five minutes. I stumbled out of the bar in shock. I felt like I was floating two feet above the ground.

Bracelet in brazed brass on steel plated with 22-karat gold, 1965

Coltrane freed up my thinking by breaking with the orthodox. I could see anything was possible. I went back to the welding shed and within a week I had my thesis."[6] Jocz's *Coltrane* sculptures were full of movement.

Jocz was also influenced by the work of Philip Guston (1913–1980), whose canvases in the 1970s featured hooded Klansmen and other politically charged imagery executed in an intentionally clumsy, cartoonish manner. The negative reaction was so strong that when Jocz went to Marlborough Gallery to purchase a catalogue, the staff hid them. When Guston lectured at Boston University, Jocz witnessed a chaotic scene erupt with shouts and protests from the audience. He was amazed to see Guston quietly endure the turbulence around him, saying simply, "I am just a painter." Jocz felt that Guston, like Coltrane, liberated young artists from entrenched rules.

Jocz attended grad school at the University of Massachusetts, Amherst, and taught his first classes. After graduation, he found steady work as a maker and designer of acrylic furniture and accessories. These jobs paid well, and he enjoyed product design and development, but at the same time he studied with a local artist, Joan Carriere. Jocz said, "Joan taught me that I could apply my sculptural ideas to jewelry."[7] By the late 1970s, Jocz wanted to become a studio jeweler. With the encouragement of his wife, Katherine Bock Jocz, an editor and author who wholeheartedly supported his artistic talents, Jocz began making jewelry on his own.

EARLY WORK:
"In a way I felt I had nothing to do with it."

By the mid-1980s, a body of work emerged that combined Jocz's interest in sculpture with an intense focus on technique. *Line Logic* exemplifies the energy and power Jocz was capable of investing in a single object. The bracelet's hollow-formed boxes have a monolithic appearance softened with lines of inlaid gold. Precise, hand-made hinges transform the bracelet, which looks completely different on the wrist than when laid out straight (pp. 46–7). He moved away from hinges in the *Free Jazz* bracelet series that experimented with vigorous loops and angles, all hollow formed, that almost belied their function (p. 50).

The 1990s opened with an investigation of the ring. He said, "I like the ring form because it makes a unified sculptural statement, allowing both formality and freedom. The constraint of the finger hole is great to play with sculpturally, sometimes adding a note of surprise or sometimes being celebrated, but most often its utilitarian purpose disappears in my work."[8] He explored figurative and sculptural ideas, and the shaft in relation to ornament. In the *Zuc* series, he used wires to sketch lively plant-like shapes (pp. 71–5), and in *Caged Stones* he placed loose gemstones within geometric cages in a rejection of the reverence normally accorded them (pp. 68–9).

The most exciting work to emerge from this group was the *Protos* series, which demonstrates that Jocz thinks big and in brilliant color, even in intimate scale (pp. 76–9). Jocz used polymer clay to create inchoate, embryonic, and inexplicably vital shapes atop rings. He experimented with the material overlaying the industrially

One of six *Coltrane* sculptures Jocz created for his thesis, 1966

colored clay with dry pigment for an intense burst of color that accentuated his curious shapes. Jocz said, "I despised the material and that was the catalyst. In my frustration, I tore it apart and set it atop some silver rings sitting on my bench. When I saw the rings, they had transformed. They had presence. In a way I felt I had nothing to do with it."[9]

By 1990, Jocz was fully ensconced in the studio art world by virtue of his outsize talent and technical skills. He showed his work regularly and taught in Boston-area jewelry departments—unusual for someone who did not formally study in the field. At the Massachusetts College of Art & Design he became friendly with Joe Wood and Rebecca Brannon, who were married, and the trio had many lively dinner parties together.

Jocz and Wood increased contemporary jewelry's visibility in Boston by mounting an exhibition called *Epiphanies*.[10] The participating artists were rising stars drawn from New England and New York. Calling the collection "portable works of art," the curators placed special emphasis on the creative nature of the objects, knowing that the public, even by this point, had little understanding of jewelry as more than a charming accessory.

For Jocz, the exhibition was an exhausting but exhilarating endeavor that strengthened his confidence in leading the discourse surrounding his field. Since then, he has published essays that address the creative process. In 1995, he produced the first curated "Exhibition in Print" issue for *Metalsmith* magazine, with risk and reverence as its theme. Jocz wrote movingly about challenging norms and "giving up to the materials and the process while seeking new vision and . . . gambl[ing] with possible failure."[11]

NARRATIVE BROOCHES:
"Personal response to life forces and mortality."

In contrast to the purely sculptural shapes of the *Protos* rings, Jocz created the introspective, improvisational *Sketchbook* series, featuring landscapes and street-life scenes from a personal viewpoint (pp. 96–103). He carried a small piece of silver in his pocket, sketching directly on it to capture his travels, moments in his day, or special memories.

As Jocz put it, "I approach it with a folk attitude using at-hand, technically simple means to quickly make a statement. I occasionally carry in my pocket two-by-three-inch pieces of silver and draw directly on the metal with a marker, using sandpaper as an eraser. Later, I pierce or saw the piece, freely following the drawn lines. I then bend, form, and texture the silver to give it three dimensionality, and lastly, paint with acrylics."[12] This was a very direct way of working, as if on paper. Cutting and pushing the metal was a means of investing a tiny object with the sense of deep space; he returned to this method later, on a larger scale, in his *Portraits* series.

Some examples revolved around coffee drinking and the implied conversations, internal and external, that could take place around the beverage (among friends, Jocz is well-known for his barista skills). Others are views of Tuscany, Mitla, and locations where he traveled. They resemble a series of fleeting snapshots with a first-person perspec-

Daniel Jocz's work bench in Cambridge, MA, in 1992 with several works in process, including *Breakfast at Penland* (p. 102) and *Rain Hat* (p. 149)

tive. This sense of immediacy is heightened by his plein-air brushwork and the artist's hand shown in the foreground, painting, smoking, or drinking coffee.

The *Song* series shares this sense of immediacy and the study of perspective. A *Starry Night in Tyringham Orion* (1994) is dominated by the artist's finger pointing toward the constellation far above the landscape (p. 82). Repoussé in Jocz's hands resulted in a sensuous surface, and he turned his hand to depicting intimate anatomies, flowers, fruit, and some overactive sperm.

He returned to this format in 2011 for *Punch*, which depicts the instant a fist makes contact with an opponent's face (pp. 94–5). It was created for the exhibition *Brooching It Diplomatically: A Tribute to Madeleine K. Albright*. Jocz said, "To me diplomacy sometimes becomes a form of verbal punching. Though the piece may seem to be a contradiction to diplomacy, it is how I see Madeleine Albright, as a person able to deliver the ultimate punch in negotiations."[13]

The *Song* series and *Punch* experiments with pushing picture plane forward in a manner that confronts the viewer. For the artist, they have been a "personal response to life forces and mortality."[14]

The mystery of life and death became a troubling and inescapable subject for Jocz after the fall of the Twin Towers in 2001. The shocking violence of the attack unmoored him, and, like many, he could not make sense of the world. He said, "Creativity and art seemed ridiculous, and reason seemed lost to me."[15]

"It just seemed like my mind was bleeding or my art was bleeding," he said.[16] That image became *Libera Me*, a small, rectangular brooch pierced by red drops of glass that made it seem as if the brooch were weeping blood (p. 109). Jocz turned to the

requiem, a solemn religious event that honors the dead and offers solace to the living. He attended a performance by the Boston Symphony Orchestra of Hector Berlioz's *Grande Messe des morts* (or Requiem), Op. 5, (1837), a libretto drawn from the Latin Requiem Mass. Deeply moved by this experience, Jocz realized the music and text complemented his search for visual expression.

When he was finished, a year and a half later, Jocz had produced the six brooches in the *American Requiem 3047.9.11.2001* series, each informed by musical cues translated into sculpture and paired with a title and text from a requiem by Verdi, Mozart, and others (pp. 108–13). The most poignant example of these stirring works is *Hostias*, a dark brooch with a fragmented, shattered appearance flecked with X shapes made of granulated gold. The composition is open to interpretation, but to this writer they are an abstract rendering of the shattered towers and plummeting bodies that the world witnessed on that terrible day. Too important to be casually worn, the entire series resides in the Farago Collection at the Museum of Fine Arts, Boston.

FASHION STATEMENTS, EROTIC AND OTHERWISE: "An object can just be fun."

From his early days, fashion exerted a powerful attraction for Jocz, who recalled being fascinated with issues of *Harper's Bazaar*, which he read as a kid. "I've always been interested in the idea of fashion as something not to be taken so seriously but to be full of exuberance and fun."[17] In the late 1990s, he fashioned a Bing cherry pendant that was equal parts innocence and eroticism (p. 143). Covered with a luscious red enamel, the cherries have a sensual appeal.

Fun to make, and fun to wear; this success led him to consider other fantasies. He turned to film icon Marlene Dietrich, who was often pictured holding a cigarette with nonchalance. Jocz created realistic enamel cigarettes that appear burned to a nub, lightly crumpled, and complete with lipstick smudges and ashen embers (p. 140). The erstwhile cherry, a match, and a cherry stem completed the effect when Jocz arranged this group into a necklace he called *Marlene's Dijes*, using the Spanish term for trinkets or charms and referencing the power of *milagros*, the religious good luck charms used in Mexico and elsewhere. The resulting necklace is both alluring and trashy (p. 141).

He said, "I'm also playing in this piece with passion and romance and maybe with disgust in terms of the iconic and symbolic meaning of 'cigarette.' I started to have fun working with these ideas about how we look at work and imagery and how it affects us in some way. Do we view *Marlene's Dijes* with disgust or longing? Or a sensual moment that is almost embarrassing us? This is the emotional stuff that I want to see if I can get in my work."[18]

His next about-face, the *Candy Wear* series, was a riot of color. His goal was to create a soft and fuzzy surface like flocked wallpaper. Adding flocked rayon fibers to a metal surface was a big challenge. First, he created simple graphic forms, like X and O brooches, circle bracelets, and dramatic V-shaped necklaces out of hollow tubes using a combination of electroforming, rapid prototyping, and hand-making skills. Then

The artist, Daniel Jocz

he experimented with flocking guns and glues to obtain the dense, plush surface. The results were astonishing: a surface that was as brightly colored as enamel but fuzzy like a plush toy. Wearers could enjoy the conflicting aspects of the jewelry, made into bracelets, hair ornaments, and necklaces, in its soft and hard state (pp. 154–65).

The playful appeal of this series pointed to another aspect of Jocz's approach to making. He said, "I feel that an object can just be fun. It can contain wonder and nothing else. That's what I am trying to work out in this new flocked series, along with the fact that I've always wanted to make a series of fashion jewelry. Fashion is like candy, the kind of candy that you bought when you went to the store when you were a little kid. You buy this sweet stuff and put it in your mouth, and it hits you, kapowie, and five minutes later it's gone. But it was fun. And you want to do it again. This is kind of how I see fashion jewelry, at least the kind of fashion jewelry I'm interested in."[19]

Jocz experimented with aluminum, pushing the material with a series of drilled and carved bracelets that were anodized, flocked, acid-etched, and otherwise ornamented. The sheer physical effort involved is reminiscent of Michelangelo's approach

to marble — to free the figure within. A collection of large bracelets emerged. One slender example stands out: a three-dimensional calligraphic squiggle featuring a rich black surface. The delicate twists and swelling lines belie the arduous efforts involved in its creation (p. 130).

His next fashion series was a reinvention of the prim, pleated, high collar ruffs worn by the aristocracy and the merchant class in Europe around 1600, *American Riff on the Millstone Ruff*. Known colloquially as "millstone" ruffs after circular grinding stones, ruffs became larger, more complex, and unwieldy over time, a starched symbol of wealth and status. Riffing on the history of the ruff was fun, but what especially excited Jocz was the new platform he had found using wide neck ornaments to stage his designs. Since a large surface made of precious metals would be expensive to produce and heavy to wear, Jocz turned to aluminum, a lighter material that had already shown promise in other experiments, but he didn't know what the decoration would be.

The answer came while Jocz was watching shows on customizing motorcycles; it struck him that making jewelry wasn't that different. As Patricia Harris and David Lyon have wryly noted, the artist "has a penchant for working at the intersection of kitsch and high art."[20] Autobody decoration offered the methods and materials he was looking for. The surfaces of the ruffs were airbrushed with automotive lacquers to produce a gleaming surface.

Jocz synthesized a series of five large ruffs, each of them unique in shape and attitude. One white example sported large horns on a fractured iceberg landscape (p. 176), while another featured floating flame designs like those found on hot rods (pp. 171–2). A colorful third drew directly from graffiti (p. 173). The results bore little evidence of the considerable handwork involved in their creation and leaned heavily into Pop culture. Pleased with the results, the ruffs debuted first in the Netherlands at Galerie Marzee before making a splash at SOFA New York in 2008.[21] Jocz hired students as models, and makeup artists to give them a chic look. They sauntered in, catwalk style, to the sound of thumping bass in a raucous performance for the craft world.

WALL ART:
"Loud, disrespectful, and fun."

Next, Jocz moved on to wall sculpture. Sticking with aluminum, which had proved an excellent material for his ruffs, he discovered that corrugated aluminum board was perfect for his needs, with sufficient resistance for him to rip, cut, and shape to his desire, and then spray paint. Jocz called the series *Just Like Garage Band* for the music he blasted while working. *The Boston Globe* called the work "loud, disrespectful, and fun."[22] The raw, explosive nature of the abstract examples is almost shocking. The surface is heavily shredded in some examples, leaving a narrow frame and ripped metal hanging below (pp. 196–7).

He quickly moved on to portraits, working on several canvases at once to capture the essence of his friends, colleagues, and his wife, Katherine. Their genesis can be traced to his *Sketchbook* series from the early 1990s. Some are more humorous than

others. A portrait of the painter George Hildrew includes two cartoonishly long tubes that protrude from the subject's eyes (p. 185). *Metaphoric Self-Portrait at 80* depicts a car on fire with hellish red flames shooting upward, and the black smoke billowing out seems more funny than tragic (p. 193). Jocz said, "That's me in the car, speeding, trying to get as much in as I can. The car's on fire. I'm on fire. I may not last. I'm driving by the graveyard, enjoying life."[23]

THE END IS THE BEGINNING

Why has Jocz explored so many wildly varied forms in his career? Jocz described the Folding Tent Theory, a philosophy he learned from artist Julio Granada "after a few *caipirinhas*, that infamous high-octane Brazilian drink."[24] The idea states that the lifespan of arts organizations should be limited, in order to prevent calcification and entrenchment. In other words, "Like a circus, the organization should come to town, give its show, fold its tent, and then leave." They gauged that two and a half years was sufficient for a successful organization.

Jocz embodied this ideology in his career even before he understood it. Each evolution was explored, presented, and set aside in favor of the new excitement. This has led to a body of work that is full of color, texture, meaning, fun, life, sadness, and joy. Every afficionado of art jewelry can find something to celebrate in Jocz's work, and heated discussions might even ensue over what is most successful, or most impactful.

And what's next for the artist? It could be anything.

1 Prisca DeGroat, "Wearable Lightness of Design," *GZ Art + Design, International Jewelry Magazine*, Vol. 7 (February 2008): pp. 8–10.

2 Robert Godfrey, "On the Fringe: An Interview with Daniel Jocz," in *Daniel Jocz, Uncommon Sense: A Retrospective Exhibition* (Cullowhee, NC: Belk Gallery, 2000), p. 21.

3 This quotation, and all activities and comments made by the artist, in quotes or in the body of the text, unless otherwise noted, are drawn from an interview conducted by the author with the artist at his home in Tyringham, Massachusetts, on June 6 and 13, 2022.

4 The Philadelphia College of Art is now the University of the Arts.

5 Philip Pavia, *Club Without Walls: Selections from the Journals of Philip Pavia* (New York: Midmarch Arts, 2007).

6 As told to Sarah Davis, Oct. 5, 2022.

7 Ibid.

8 Daniel Jocz, artist's statement, cited in Susan Grant Lewin, *One of a Kind: American Art Jewelry* (New York: Harry N. Abrams, Inc., 1994), n. 13.

9 As told to Sarah Davis.

10 Catherine Mayes, Daniel Jocz, and Joe Wood, *Jewelries/Epiphanies* (Boston: Artist Foundation, 1990). In addition to Jocz and Wood, participating artists included Boris Bally, Eva Eisler, Sandra Enterline, Thomas Gentille, Lisa Gralnick, Susan Hamlet, John Iverson, Allison Macgeorge, Pavel Opocensky, Joan Parcher, Claire Sanford, Jill Slosburg-Ackerman, Lisa Spiros, Didi Suydam, and Alan Burton Thompson.

11 Daniel Jocz, "Meaning in Jewelry: Risk and Reverence," *Metalsmith*, 1995 Exhibition in Print: pp. 3–8.

12 "Artist's statement: Daniel Jocz," *Ornament*, Vol. 17, No. 2 (Winter 1993).

13 Helen Drutt, *Brooching It Diplomatically: A Tribute to Madeleine K. Albright* (Stuttgart: Arnoldsche, 2000), p. 66.

14 "Artist statement: Daniel Jocz," *Metalsmith*, 1994 Exhibition in Print.

15 "Statement," *American Requiem 3047.9.11.2001*, brochure.

16 Paul Massari, "Daniel Jocz, Eternal Rest, Perpetual Light," *Metalsmith*, Vol. 26, No. 3 (Spring 2003): pp. 40–45.

17 Patricia Harris and David Lyon, "Daniel Jocz: Ruffing Up History: The Artist Merges Seventeenth-Century Fashion with Contemporary Motorcycle Art in His Take on the Millstone Ruff," *Metalsmith*, Vol. 29, No. 2 (2009): p. 24.

18 Robert Godfrey, "On the Fringe: An Interview with Daniel Jocz," in *Daniel Jocz, Uncommon Sense*, p. 18.

19 Bärbel Helmert and Paula Owen, *Zierat: Zeitgenössischer Schmuck aus USA, Niederlande und Deutschland* (Darmstadt: Hausser Verlag, 2001), cat. 34.

20 Harris and Lyon, p. 25.

21 SOFA (Sculpture, Objects, and Functional Arts).

22 Kate McQuaid, "In Jewelry and Otherwise, Artists Confound Expectations," *The Boston Globe*, June 2, 2015.

23 McQuaid, p. 15.

24 Daniel Jocz, "Organizing and Moving On: Artists and the Folding Tent Theory," *Crits: Discourses on the Visual Arts*. [Western Carolina University, Department of Art,] 1993.

CATALOGUE
OF WORKS

SCULPTURAL CONCERNS

STICKS, necklace, 1986
Silver, gold
Working drawing on endpapers

RAIN FRAMES, necklace, 1984
Silver, gold
Working drawing on overleaf

43

24 gyge silver gold

22 gago

6 Small
6 Large

$17\frac{1}{8}'' - 17\frac{1}{2}''$

Working Drawing
"Rain Frames"
1984 — Jocz

LINE LOGIC, bracelet, 1984
Coltrane series
Silver, gold
Private collection

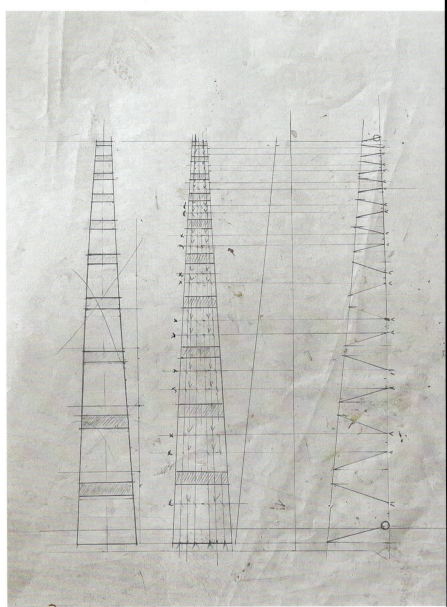

TAPER, bracelet, 1983
Coltrane series
Silver, gold
With working drawing
Private collection

Opposite top:
TOUR, bracelet, 1989
Free Jazz series
Silver, nickel
Cartoon on p. 62, bottom

Opposite bottom:
PEACH, bracelet, 1987
Free Jazz series
Silver, gold

Above:
TRIANGLE, bracelet, 1988
Free Jazz series
Silver, gold

Right:
Model wearing jewelry, circa 1989

Cartoon from *Coltrane* series, unmade, 1986

GEO-DRAWING, bracelet, 1988
Free Jazz series
Silver, gold
The Daphne Farago Collection,
Museum of Fine Arts, Boston

Top:
BROOCHES, 1988
Leftovers series
Silver, gold

SOUFFLÉ, sculpture, 1992
Serenade series
Fiberglass and gold leaf
With cartoon

AMPHORA, sculpture, 1992
Serenade series
Fiberglass and gold leaf
With cartoon

THE MUSE LEAVES, ring, 1990
Ceremonies of the City series
Silver, nickel, gold
With cartoon

Opposite:

Top left:
SHELTER, ring, 1988
Ceremonies of the City series
Silver, gold

Top right:
WORK, ring, 1988
Ceremonies of the City series
Silver, yellow and pink gold
Helen Williams Drutt Collection,
The Museum of Fine Arts, Houston

Bottom left:
FLAGS, ring, 1989
Ceremonies of the City series
Silver, nickel, copper, gold
With cartoon

Bottom right:
VESSEL, ring, 1988
Ceremonies of the City series
Silver, gold
Private collection

THE BEE STINGS, **THE BEE DANCES AKA ECHO**, ring, 1990
Sculpture series
Silver, gold, nickel, beeswax, cotton thread

LETTERS, ring, 1990
Sculpture series
Silver, gold
Cartoon, p. 62, bottom

LOUDMOUTH, ring, 1990
Sculpture series
Silver, nickel, gold
Cartoon, p. 62, bottom
Private collection

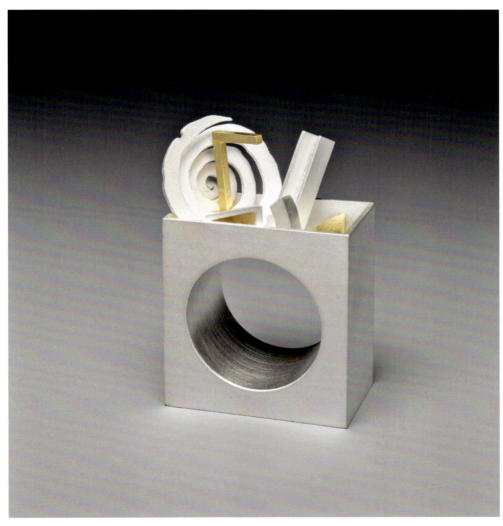

ICEBERG series of five rings, 1992
Silver, gold, tourmaline, sapphire
Opposite, right two rings: Helen Williams Drutt Collection,
The Museum of Fine Arts, Houston
Above: Collection of Joe Wood

CAGED STONE series, 7 shown of 13 rings, 1991–1992
Silver, gold, sapphire, garnet
Private collections

Ring from *Zuc* series of 13 rings, 1991–1992
Silver, gold

Rings from *Zuc* series of 13 rings, 1991–1992
Silver, gold
With cartoons
Above: Susan Grant Lewin Collection,
SCAD Museum of Art, Savannah, GA

Rings from *Zuc* series of 13 rings, 1991–1992
Silver, gold

Rings from *Protos* series, 1991–1993
Nickel, polymer clay, dry pigment
Opposite: The Daphne Farago Collection,
Museum of Fine Arts, Boston
Above: Museum of Arts and Design, New York

Rings from *Protos* series, 1991–1993
Nickel, polymer clay, dry pigment
Above: Susan Grant Lewin Collection,
SCAD Museum of Art, Savannah, GA

TELLING TALES

A STARRY NIGHT IN TYRINGHAM, ORION, brooch, 1994
Song series
Silver, 9 diamonds
With cartoon
Private collection

AURORA, brooch, 1995
Song series
Silver, acrylic paint
With cartoon

JUST LIKE SPRING RAIN/ROSE PETALS,
MAIDENHAIR FERNS, brooch, 1994
Song series
Silver, polymer clay, fluorescent dry pigment

PEAR ON A PEAR PLATE, brooch, 1994
Song series
Silver, gold leaf
Private collection

NIGHTINGALES, brooch, 1994
Song series
Silver, gold
Smithsonian American Art Museum, Washington, D.C.

OBLATES DE SWAN, brooch, 1994
Song series
Silver, polymer clay

POSTCARD FROM TUSCANY, brooch, 1995
Song series
Silver, acrylic paint
With cartoon
Donna Schneier Collection,
The Metropolitan Museum of Art, New York

Top:
DREAM REMEMBERED-KISS, brooch, 1998
Song series
Silver

JOURNEY THROUGH DARK HEAT (BOB DYLAN),
brooch, 1996
Song series
Silver, gold, acrylic paint

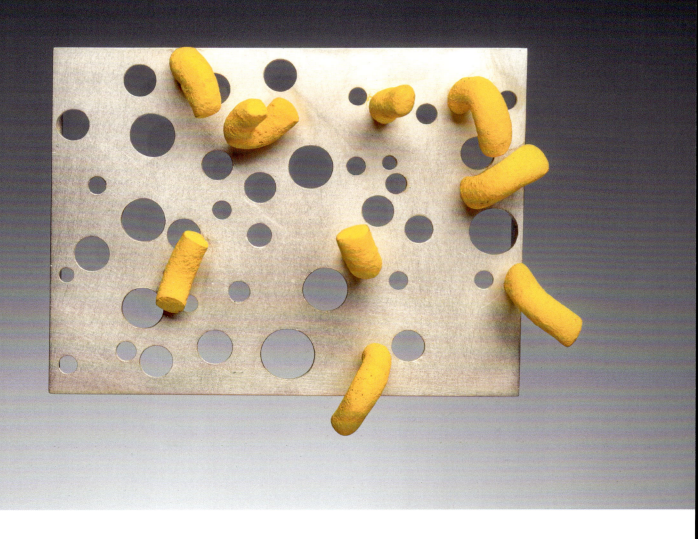

CHEETOZ, brooch, 1994
Screens series
Silver, polymer clay, dry pigment

RAIN MAKES WHEAT MAKES BREADS, brooch, 1994
Screens series
Silver, polymer clay, dry pigment
Helen Williams Drutt Collection,
The Museum of Fine Arts, Houston

Opposite:
RETABLOS: MICKEY TROUBLE (*top*)
NECESSITIES AND BAD HABITS
(*bottom*), brooches, 1998
Song series
Silver
With screen prints

Who is being punched?
You or me? Who is changing
their mind? Who punched? You?

PUNCH, brooch, 1997
Song series, made for the exhibition *Brooching it Diplomatically:*
A Tribute to Madeleine K. Albright
Gold
With cartoon and haiku
Private collection

TOSCANA, brooch, 1993
Sketchbook series of 14 brooches
Silver, acrylic paint
Die Neue Sammlung—The Design Museum, Munich, Germany

PAINTING LEMONS AT HORIZONS, brooch, 1993
Sketchbook series of 14 brooches
Silver, acrylic paint

SUNSET CENTRAL FRANCE, A STATE OF MIND, brooch, 1993
Sketchbook series of 14 brooches
Silver, acrylic paint
Collection Patti Bleicher/Loupe Gallery, Montclair, NJ

LUCERNE, SWITZERLAND, WITH SYRINGES, brooch, 1993
Sketchbook series of 14 brooches
Silver, acrylic paint

Opposite:
MARKET AT MITLA, brooch, 1992
Sketchbook series of 14 brooches
Silver, acrylic paint

BACK COURTYARD, MUSEO ERVIN FRISSELL, MITLA, brooch, 1992
Sketchbook series of 14 brooches
Silver, acrylic paint

Above:
VIEW FROM MOUNTAIN, MITLA, brooch, 1992
Sketchbook series of 14 brooches
Silver, acrylic paint

BREAKFAST AT PENLAND, brooch, 1992
Sketchbook series of 14 brooches
Silver, acrylic paint

TEA AT BEAN STREETS, ASHEVILLE,
NORTH CAROLINA, brooch, 1993
Sketchbook series of 14 brooches
Silver, acrylic paint

103

ZUCCHINI LIPS, **CHERRY EYES**, and **BANANA FACE**, brooches, 1997
Fruit Faces series
Silver, enamel, sapphire, amethyst
Opposite bottom: Racine Art Museum, Racine, WI

ANGEL, NOUS, DOM, brooches, 2001
Ode to a Personality (Miguel Angel Corzo) series
Silver

REQUIEM AETERNUM, brooch, 2002
American Requiem 3047.9.11.2001 series of six brooches (see p. 204)
Silver, gold leaf
The Daphne Farago Collection,
Museum of Fine Arts, Boston

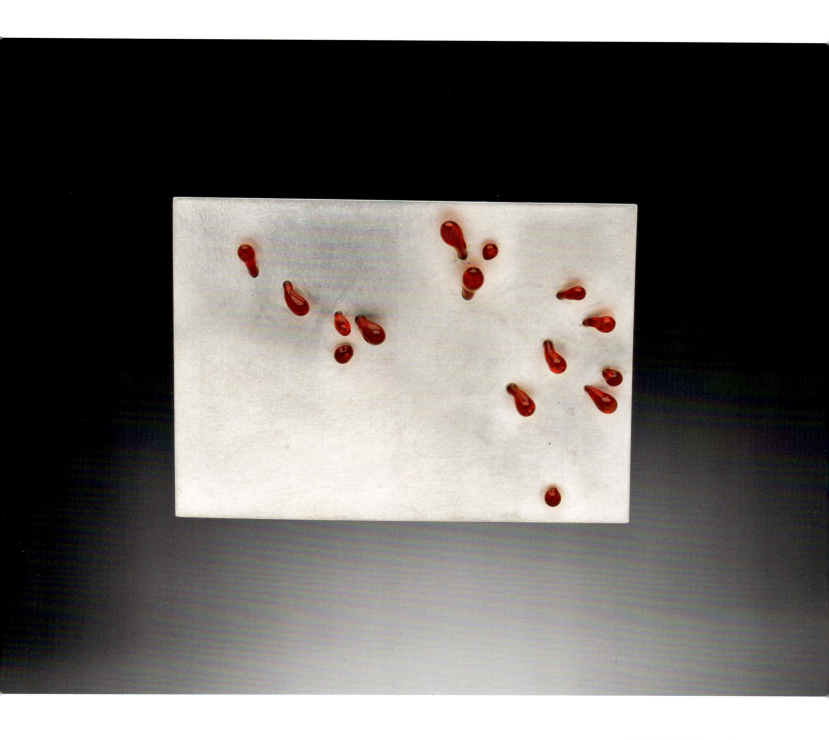

LIBERA ME, brooch, 2002
American Requiem 3047.9.11.2001 series of six brooches (see p. 204)
Silver, glass
The Daphne Farago Collection,
Museum of Fine Arts, Boston

DIES IRAE & TUBA MIRUM, brooch, 2002
American Requiem 3047.9.11.2001 series of six brooches (see p. 204)
Silver, gold, sapphire
The Daphne Farago Collection,
Museum of Fine Arts, Boston

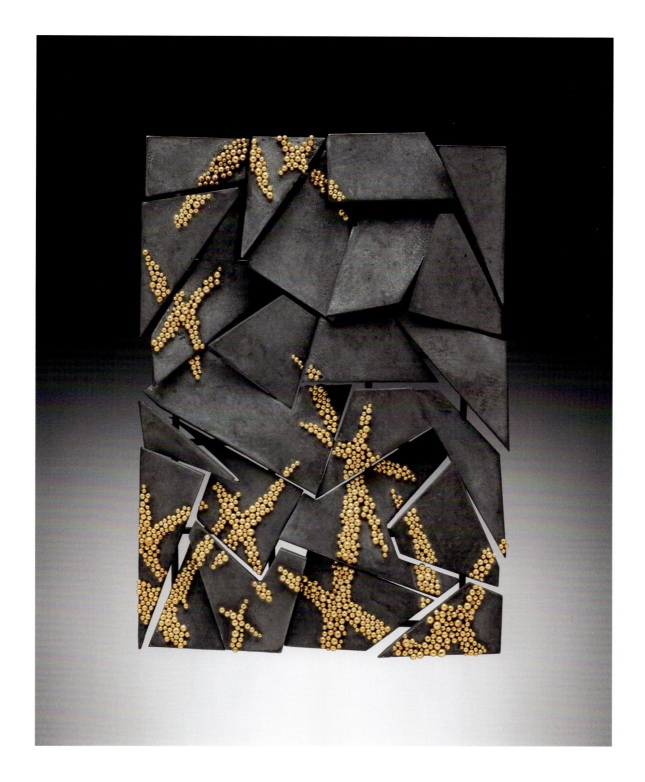

HOSTIAS, brooch, 2002
American Requiem 3047.9.11.2001 series of six brooches (see p. 204)
Silver, gold
The Daphne Farago Collection,
Museum of Fine Arts, Boston

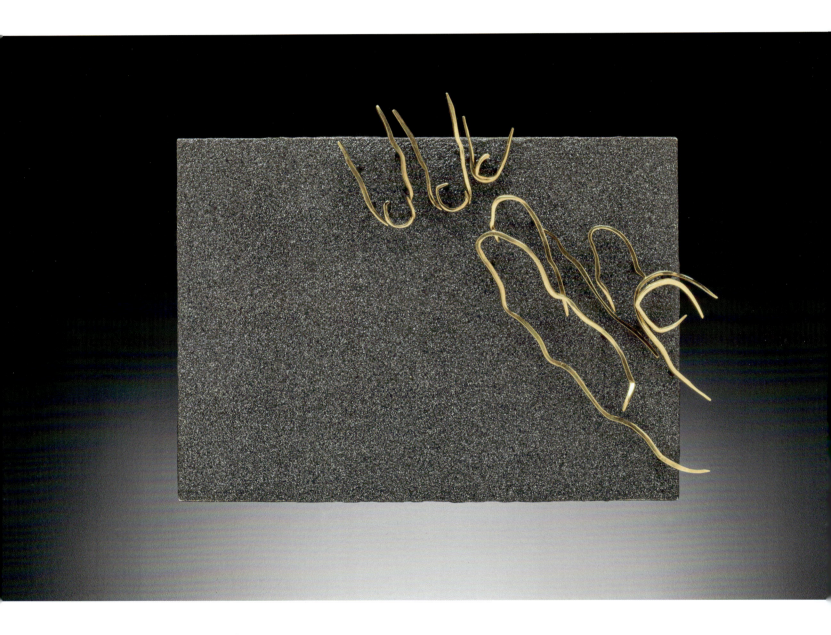

OFFERTORIUM DOMINE, brooch, 2002
American Requiem 3047.9.11.2001 series of six brooches (see p. 204)
Silver, gold
The Daphne Farago Collection,
Museum of Fine Arts, Boston

AGNUS DEI, brooch, 2002
American Requiem 3047.9.11.2001 series of six brooches (see p. 204)
Silver, gold
The Daphne Farago Collection,
Museum of Fine Arts, Boston

CARVING, BENDING, FLOCKING:
ALUMINUM THREE WAYS

ORANGE EXPLO, bracelet, 2004
Aluminum Three Ways series
Aluminum, rayon flock, rubber
Private Collection

Opposite: Model wearing *Orange Explo* at Design Miami, circa 2005

CHARTREUSE EXPLO, bracelet, 2004
Aluminum Three Ways series
Aluminum, rayon flock, rubber
With cartoon

DANCE, bracelet, 2005
Aluminum Three Ways series
Anodized aluminum

BUBBLE BATH, bracelet, 2004
Aluminum Three Ways series
Anodized aluminum

Color study over copy of original cartoon

RIBBON, bracelet, 2005
Aluminum Three Ways series
Anodized aluminum, rubber

Aluminum works in process, pre anodizing

MEDUSA, bracelet, 2004
Aluminum Three Ways series
Anodized aluminum
In process photo opposite, center

SPIDER, bracelet, 2004
Aluminum Three Ways series
Anodized aluminum
In process photo, p. 124, left

FLAME FLOWER, bracelet, 2004
Aluminum Three Ways series
Anodized aluminum
In process photo, p. 124, right

NEWS PRINT, bracelet, 2005
Aluminum Three Ways series
Anodized aluminum
Yale University Art Gallery, Gift of Susan Grant Lewin

BLUE FLOWER, bracelet, 2005
Aluminum Three Ways series
Anodized aluminum

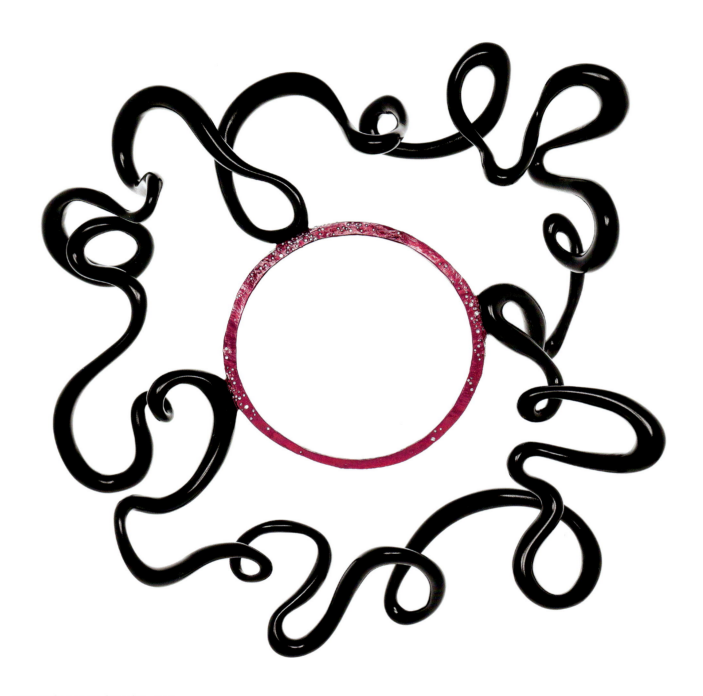

BILLET/BALLET, bracelet, 2007
Aluminum Three Ways series
Anodized aluminum
Opposite top: Color study over copy of original cartoon
Opposite bottom: Aluminum carving work in process

DIRTY WORDS, bracelet, 2006 (see p. 204)
Aluminum Three Ways series
Anodized aluminum
Donna Schneier Collection,
The Metropolitan Museum of Art, New York

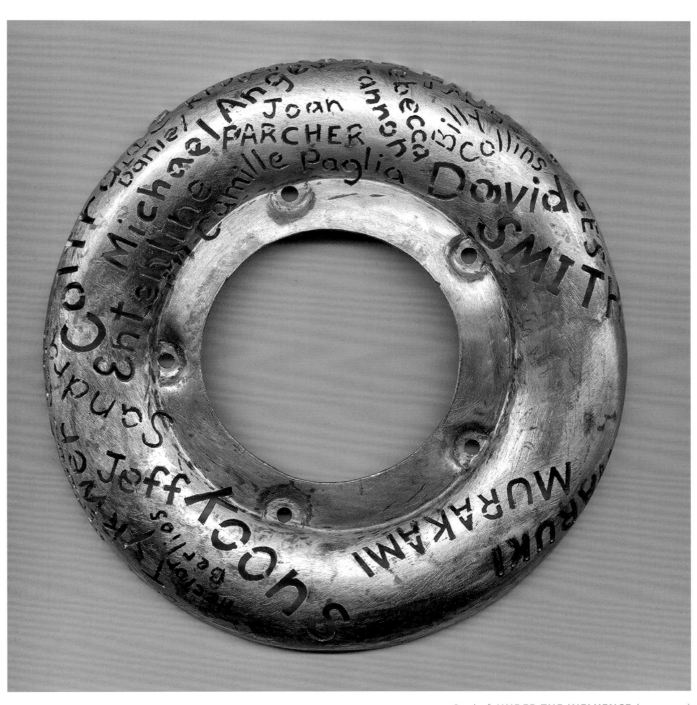

Overleaf: **UNDER THE INFLUENCE** (see p. 205)
Aluminum Three Ways series
Anodized aluminum
The Daphne Farago Collection,
Museum of Fine Arts, Boston
Above: Aluminum piercing work in progress

SERIES OF DREAMS

Marlene Dietrich

GAMBLE, necklace, 1997 (see p. 205)
Marlene Half a Pack series
Silver, copper, enamel

GAMBLE, necklaces, 1997
Marlene Half a Pack series
Silver, copper, enamel

MARLENE DIJES, necklace, 1998
Marlene series
Silver, gold, enamel, sapphire, garnet
Private collection

5 CHERRIES, necklace, 1997
Marlene series
Silver, gold, enamel
Private collection, New York

CHERRY SOLITAIRE, necklace, 1997
Marlene series
Silver, gold, enamel

was the ring a gray color

or sort of silver-ish in
color? The inside was

fuzzy though and I remember
it was pink or

was it sort of orange? I remember
the ring was

a cube with a round hole
through,

definitely -

INCONSISTENCY OF MEMORY, two rings, 2008
Silver, rayon flock
With haiku

JOE BLOW, chatelaine, 2006 (see p. 206)
Silver, leather, rubber band, pencil, scotch tape, plastic straw,
super glue, paper clip, paper
Nationalmuseum, Stockholm, Sweden,
Gift of Helen Drutt

Daniel Jocz wearing *Rain Hat*

RAIN HAT, hat, 1988 (see p. 206)
Personal fountains series
Felt, rubber, water

DOG TOTE #2, 2021
#1 made in 2006 (see p. 206)
Leather, chromed brass

CANDY WEAR

Subtle sparkles.
Ralph Lauren

SAKS
FIFTH
AVENUE

Design collages made with *New York Times* fashion advertisement and sticky dots, 1999

TIARA, 2000 (see p. 206)
Candy Wear series
Silver, copper, rayon flock
The Susan Grant Lewin Collection,
Cooper Hewitt, Smithsonian Design Museum, New York

BRACELETS, 2000
Candy Wear series
Silver, rayon flock, magnet

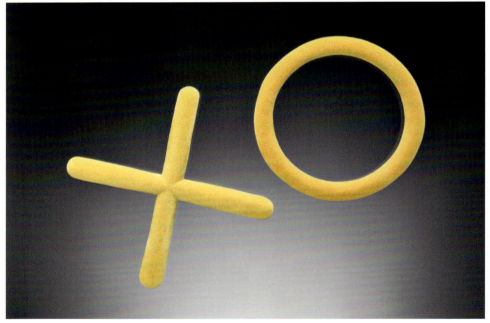

XOXO, brooches, 2000
Candy Wear series
Silver, rayon flock

XOXO brooches at Ornamentum
Gallery, Hudson, NY, 2011
Small "x": Asheville Art Museum,
Asheville, NC

NECKLACE, 2000
Candy Wear series
Silver, rayon flock, magnet

159

TIARA, BRACELETS, and **BROOCH,** 2000
Candy Wear series
The Susan Grant Lewin Collection,
Cooper Hewitt, Smithsonian Design Museum, New York

NECKLACES, 2000
Candy Wear series
Silver, rayon flock, magnet

Opposite: **BROOCHES**, 2000
Candy Wear series
Silver, rayon flock

BRACELETS, 2000
Candy Wear series
Silver, rayon flock, magnet
Top: Gift of Noel Guyomarc'h,
Montreal Museum of Fine Arts, Canada
Above: Schmuckmuseum, Pforzheim, Germany
Opposite center: National Museum of Scotland

NECKLACES, 1998
Happy Pears series
Silver, rayon flock

AMERICAN RIFF ON
THE MILLSTONE RUFF

FIRE WATER, collar, 2007
American Riff on the Millstone Ruff series
Aluminum, copper, lacquer, chrome
Private collection
Overleaf: On model

POP ROCK DADDY, collar, 2007
American Riff on the Millstone Ruff series
Aluminum, copper, lacquer, chrome
On model

173

POT SHOTS, collar, 2007
American Riff on the Millstone Ruff series
Aluminum, copper, lacquer, chrome
On model

ROUGH RUFF, collar, 2007
American Riff on the Millstone Ruff series
Aluminum, copper, lacquer, chrome
Museum of Arts and Design, New York
On model

CRASH ANGEL, collar, 2007
American Riff on the Millstone Ruff series
Aluminum, copper, lacquer, chrome
On model

2000s

Portrait of student wearing *Pot Shots*, 2007 (pp. 174–5)
The Netherlands

1600s

PORTRAIT OF HAESJE JACOBSDR VAN CLEYBURG,
Rembrandt van Rijn, 1634
Rijksmuseum, Amsterdam, Netherlands

Detail of **POP ROCK DADDY** (p. 173)

RIPPING, SHREDDING, SPRAYING

ARTHUR, PHOTOGRAPHER, PRINTMAKER (ARTHUR HILLMAN),
4x4' wall panel, 2017–2022
Portraits of Artist Friends series
Ripped and shredded aluminum, spray paint

GEORGE, PAINTER, PRINTMAKER (GEORGE HILLDREW),
4x4' wall panel, 2017–2022
Portraits of Artist Friends series
Ripped and shredded aluminum, spray paint

Installation, BoJo Gallery, Hudson, New York, 2019

LISA, PAINTER (LISA BARTOLOZZI), 4x4' wall panel, 2017–2022
Portraits of Artist Friends series
Ripped and shredded aluminum, spray paint

KATHERINE, AUTHOR (KATHERINE BOCK JOCZ), 4x4' wall panel, 2017–2022
Portraits of Artist Friends series
With cartoon, p. 207
Ripped and shredded aluminum, spray paint

MARY, MUSICIAN (MARY HALVORSON), 4x4' wall panel, 2017–2022
Portraits of Artist Friends series
Ripped and shredded aluminum, spray paint

SELF-PORTRAIT OF THE ARTIST, 4x4' wall panel, 2017–2022
Portraits of Artist Friends series
Ripped and shredded aluminum, spray paint

ROBERT, PAINTER (ROBERT GODFREY),
4x4' wall panel, 2017–2022
Portraits of Artist Friends series
Ripped and shredded aluminum, spray paint

LEZLIE, CHANTEUSE (LEZLIE HARRISON)/10TH AVENUE, 4PM,
CIGARETTE MEETS HOT LIPS, *4x4' wall panel, 2017–2022*
Portraits of Artist Friends series
Ripped and shredded aluminum, spray paint

METAPHORIC SELF-PORTRAIT AT 80, 4x4' wall panel, 2017–2022
Portraits of Artist Friends series
Ripped and shredded aluminum, spray paint

BOOK OF TIMES, 4x4' wall panel, 2014–2015
Just Like Garage Band series
Ripped and shredded aluminum, spray paint

Thanks To - White Hills, Sleigh Bells, Wolf Parade, Why Yes, the National, Lanterns on The Lake, Xiu Xiu, Glenn Kotche, Lonelady, Vampire Hands, Swens, Angel Olsen, Over-The Rhine, The Lumineers, Lisa Hannigan, Bat for Lashes, Clap Your Hands Say Yeah, Sun Kil Moon, Pieta Brown, Wolf Sunset Rubdown, Bob Dylan, Thea Gilmore, Beth Hart, Grouplove, Lonelady, Portico Quartet, Arcade Fire, Shiny Toy Guns, Clem Snide, Bill Frisell, Nina Simone, Billy Bragg, Silversun Pick Ups, Lemonade, Amos Lee, Yo La Tengo, Sufjan Stevens, Caroline Herring, Crystal Stilts, Maria Taylor, Now Ensemble, Sleepy Sun, Meike Foedrik, Bettye LaVette, Electric President, Inner Beach House, Gabby & Lopez, mewithoutYou, Ann Beljin, Mary Ann Redmond, Rebecca Martin, Patty Griffin, Cowboy Junkies, Firehorse, Cat Power, Deerhoof, Megafaun, Julia Holter, The Decemberists, Caribou, Diana Krall, The Lone Bellow, These New Puritans, The Pond, Solomon Burke, Cathip, Camera Obscura, Roque Ware, The Boxer Rebellion, Kendrick Scott, Jimi Hendrix, Porch Rockers, Bear McCreary, Lorde, The David Wax Museum, Fuck Buttons, Johanna Barwick for living in my Earphones!

Paul Joce

MIDNIGHT IN THE GARDEN,
4x4' wall panel, 2014–2015
Just Like Garage Band series
Ripped and shredded aluminum, spray paint

SHRED,
4x4' wall panel, 2014–2015
Just Like Garage Band series
Ripped and shredded aluminum, spray paint

ROSE, 4x4' wall panel, 2014–2015
Just Like Garage Band series
Ripped and shredded aluminum, spray paint

SMOKE, 4x4' wall panel, 2014–2015
Just Like Garage Band series
Ripped and shredded aluminum, spray paint

LOVE LETTERS (SILK PILLOWS PUMPING BLOOD),
4x4' wall panel, 2014–2015
Just Like Garage Band series
Ripped and shredded aluminum, spray paint

EXPLO, 4x4' wall panel, 2014–2015
Just Like Garage Band series
Ripped and shredded aluminum, spray paint

Hey Daniel,

How's it going? Certainly appreciated your hospitality and chat during my visit to your tower in the Berkshires. Was great crack, for sure. I'm fully ensconced in Quilty again. The weather is in its usual damp, but has become a wee bit more forgiving recently. I do worry with what is going on in Japan. We just received our first radioactive rain here in West Clare.

Had some time to reflect on my way home. Most artists, as you know, error on the side of caution, not risk. Your Bad Boy image that we talked about seems to be supported by your Bad Risk impulse. Reminds me of a bowerbird I once observed a few years ago when I was in Australia. This ungainly fellow spent his time constructing some sort of esoteric structure that he decorated with all sorts of brightly coloured things he collected from the neighbourhood including plastic forks and spoons, glass beads, berries metal bits, a watch, sea shells. Spent all sorts of hours arranging this mostly blue and metallic trash and trinkets -- treasure for him -- up and down his stick-made structure. One day he comes back with a beak full of some sort of blue juice and squirts it all over the sticks. Instant patina! Then he brings back a rather well used toothbrush and props it up. Mad, I tell you. Not sure if any other bird ever came by, or was ever seduced by this intense and playful chap. A Bad Risk creature, for sure. Ambitious. And then there is you with those semi-functioning things and memories of desire. You, holed up in that tower, just going from thing to thing, trying to get me or someone to look. You and that bird have some sort of Fado longing, I think. You make these things and expect somebody to pay attention. You show them. You wait two, three years. Maybe more. By the time somebody pays attention to you, your eye candy, you're off on something else. Sacrifice? I wonder.

Noticed that that eccentric observer of old and new art, Leo Steinberg, recently passed. Spent a lot of time musing over the sensuality of things -- including the size of the Holy Child's penis as depicted in paintings and sculpture. Thought it may have been symbolic of the born again thing. Or something like that. Steinberg looked at things the way artists do. I caught a talk by him some time ago when I was travelling through the States -- about the time I came across your work. I remember it was at a stodgy art school in the Lower Manhattan. The place sort of gave me the willies. (Your work gives me the willies, too. A different kind, though.) Place seemed to be populated by artists living off of older and dead artists. More of a feeling of a body farm than anything. I picked up the odor of Giacometti in one corner. Cézanne in another.

Just don't know why artists feel the need to feed off the corpses of other artists. Anyway I saw this flyer and decided to catch Steinberg's talk. Place smelled better when Steinberg lit up his first cigarette and lit the next from the last. All through his talk he did it. Said that Bad Risk artists are the only ones who can find their own way and appreciated them having the chutzpah to put it in front of their public. Indigestion first, he said, then faith. He thought Rauschenberg and Johns were Bad Risks right out of the barrel while deKooning and Guston became Bad Risks once they decided to reinvent themselves. Meandered his way through his talk using anecdotes and smoke.

Think you are in this Bad Risk mix, somewhere. You and the bowerbird. As I told you, you make work for a parallel universe. For instance, there's your Dreamtime and your Fado and your Noir. Makes you mediate between the intermittent and the indeterminate and the intimate. The light and the dark. Like the Aboriginal you negotiate the physical through the spiritual. Creation plus dreams. Sort of. Like the fadista singer you spin from longing to hope. By the way, since our Irish economy went sour, our melancholy pub sing-song has become really enlivened.

In a way you get sucked in to making something you never intended -- at least that's the way I see it. That romance, that passion, that temperament. Kicks you right back. And that's the tenor that underlies a good Film Noir plot, too. Like Noir you are, as you once said, on the fringe. And like that bowerbird you muddle through, oblivious of the rain.

Well enough blathering on my part. Good luck with those aluminum panels.

Cheerio, for now.

EB *Elwood Beach*
Quilty
West Clare, Ireland
27 March 2011

1. American Requiem 3047.9.11.2001 (pp. 108–13)

Requiem Aeternum
> Eternal rest give unto the dead. O lord
> And let perpetual light shine upon them
> Eternal rest give unto them, O lord
> And let perpetual light shine upon them
>> *Grande Messe des Morts* (Requiem), Op. 5
>> By Hector Berlioz

Dies Irae & Tuba Mirum
> This day, this day of wrath
> shall consume the world in ashes,
> The trumpet scattering its awful sound
> across the graves of all lands,
> summons all before the throne,
> Death and nature shall be stunned
> when mankind arises
> to render account before the judge
>> *Grande Messe des Morts* (Requiem), Op. 5
>> By Hector Berlioz

Libera me
> This day, this day of wrath,
> of calamity and misery,
> a great and bitter day,
> when you will come to judge the world by fire.
> Grant them eternal rest, O lord
> and let perpetual light shine upon them.
>> *Messe da Requiem*
>> By Giuseppe Verdi

Hostias
> To thee, O lord, we render our
> offerings and prayers with praises.
> Do thou receive them for those souls
> which we commemorate today;
> lord, let them pass from death to life
>> Requiem in D Minor (unfinished)
>> By Wolfgang Amadeus Mozart

Offertorium: Domine Jesu
> O lord,
> deliver the souls of all the departed faithful
> from the torments of hell
> and from the bottomless pit;
> deliver them from the mouth of the lion,
> lest Tartarus swallow them;
> lest they fall into the darkness
>> Requiem in D Minor (unfinished)
>> By Wolfgang Amadeus Mozart

Agnus Dei
> Eternal rest grant the dead, O lord
> and may perpetual light shine upon them,
> Eternal rest grant them, O lord,
> and may perpetual light shine upon them,
> O lord,
> for thou art merciful,
> Amen
>> *Grande Messe des Morts* (Requiem), Op. 5
>> By Hector Berlioz

2. Dirty Words (p. 132)

Abstinence Only
Abu Ghraib
Activist Judge
America's Shining Moment
Axis of Evil
Bring it On
Clean Skies
Cut and Run
Death Tax
Defeatists
Extraordinary Rendition
Evil Doers
Faith Based Initiative
FEMA
Gitmoize
Heck of a Job Brownie
I am the Decider
Intelligent Design
Mandate

Mission Accomplished
No Child Left Behind
Operation Iraqi Freedom
Orange Alert
Ownership Society
Patriot Act
People of Faith
Personal Savings Account
Plan for Victory
Prescription Drug Program
Pro Life
Same sex marriage
Terrorist Threat
Unauthorized Leaks
Un-lawful Enemy Combatant
Unpatriotic
Weapons of Mass Destruction
We're Fucked

3. Under the Influence (pp. 134–5)

The 35 names pierced onto the bracelet:

Sculptors
David Smith
David Hare
Lorenzo Bernini
Michelangelo Buonarroti

Painters
Philip Guston
Paul Georges
Robert Godfrey

Other Artists
Tim Hawkinson
Jeff Koons

Poets
Pablo Neruda
Billy Collins

Writers
Haruki Murakami
Camille Paglia
Rudolf Arnheim

Musicians
John Coltrane
Miles Davis
Ornette Coleman

Bob Dylan
Chuck D of Public Enemy

Movie Directors
Federico Fellini
Tom Tykwer

Choreographer
David Gordon

Metals
Joe Wood
Becky Brannon
Deborah Krupenia
Daniel Kruger
Jack Prip
Joan Parcher
Sandra Enterline
Olaf Skoogfors

Chef
Normand Laprise

Composers
Phillip Glass
Hector Berlioz
Bohuslav Martinu

Personal
Katherine Bock

4. Six Dates with Marlene Dietrich (pp. 138–43)

First: January, London, Dorchester Hotel
Seeing Marlene walking swiftly though the lobby of the hotel, I rush from my seat behind the palm to get closer, perhaps for a scent of her. My forward thrust is foolish. I bump into her, oddly stepping on her toe. She lets out a muffled screech though her cigarette, turns, brushing by blurts "You idiot" in a smoky halo.

　　OK, not strictly a date.

Second: China Tang Bar
Seven that evening, after a day of huffing though a cold damp London loitering around department stores for warmth, I return to the hotel and head for the bar at the rear of the lobby. I want a drink to contemplate my purchase of a pair of costly Italian gloves. I spy Marlene sitting at the bar "a few Manhattans along" it looks like. She looks up puzzled: A memory of some past connection? She nods and gives a friendly wave. Clearly not recognizing me as the jerk that stepped on her foot hours earlier. I see an opening here. But following three or four sentences between us she seems perturbed, slides off the stool with a wacky forward momentum, heads for the door, her half-smoked cigarette smoldering in an ashtray of butts on the bar. I think this is properly a second date.

Third: Late Spring, Paris
I am strolling along the Seine on an ideal spring Paris afternoon. The dinning boat *Capitaine Fracasse* is sliding past me and Cathédrale Notre-Dame de Paris, headed down river. I realize that's Marlene, mid-way towards the stern at a table by the window, surrounded by her entourage. Animated conversation, hands swinging, swirling clouds of smoke surround her. I run down the left bank waving and yelling Marlene! Marlene!

　　She waves! Or did she throw a cigarette butt out the window. I tripped over a misaligned stone in the walkway almost taking a plunge in the Seine, saved by a small tree.

Fourth: Hoboken, New Jersey, Biggies Clam Bar
Bits of clam, mustard, bread, catsup, fries, wadded napkins, ashtray full of butts. Stranded in Sinatra land; that's how Marlene described our predicament. After missed train connections to Manhattan. Did I dream this?

Fifth: Hamburg, Germany
This date I really can't talk about.

Sixth: Spring, New York, Conrad Hotel
Marlene in a robe, hair up. Me in my night silks, lost among the pillows on an extra-large king bed. We're lounging. I'm tipping down an iced sloe gin. Marlene puffing a Camel in her usual cat posture. *30 Rock* fans, we're watching the latest on the immense flat screen. Can it get any better?

Suddenly Marlene sits up on the edge of the bed, takes a few long drags on her Camel, deposits it in the ashtray, heads for the bathroom.

30 Rock had been particularly good that night. Engrossed in Liz Lemon's predicament I hadn't realized Marlene went missing. She was gone clothes and all. I never saw her again. Too busy, she tweeted from here and there.

5. Joe Blow (p. 146–7)

Joe Blow first appeared on the scene in the 1930s. In various dictionaries this guy is still defined as the average man, the typical guy. He is an American hypothetical average man. But I suspect he has brothers in other countries. While the term Joe Blow itself is in some sense a celebration of this hypothetical ordinary man, the true every-day working person is generally not celebrated in any notable way. Joe Blow seems to hang out more often in office cubicles these days. Though the bedrock worker of any corporation, Joe Blow is more often thought of by management as one of many cogs in the production wheel. Habitually, he is not recognized for his contributions in a meaningful way. He often sees that his hard work is not necessarily the path to future success. His future security might be swept away in an instant by corporate shake up. His future retirement might be rearranged to his disadvantage by corporate managers for a new profit model. Yet he stays loyal and gives the best of himself hoping that things will work out.

But in this somewhat demoralizing and perhaps alienating environment, oft-times Joe Blow's only salvation from frustration is sowing low level chaos in the office. In this he finds salvation as a human being. This chatelaine is a celebration of office high-jinks and that un-sung hero of the office "Joe Blow."

6. Rain Hat (pp. 148–9)

I wanted a hat to keep me cool in the summer. I thought, "How about a hat that rained on you. Wouldn't that be great?" It took me a long time to work out the details of making such a thing.

I wore the hat while I was giving a lecture at Western Carolina University. When the hat started to rain, people thought I was sweating profusely. They became very embarrassed for me, stifling an inclination to burst out laughing, they left the room fast.

A fedora that rains for twenty minutes, though making quite a mess, does have a cooling effect. Work must be done on the social part though. After a couple of tries wearing the hat with people retreating, I put the hat away.

Sometimes things that seem like a good idea do not work. I do miss wearing the hat.

7. Dogs are Good for Many Things (p. 151)

A much-overlooked use is as an addition to a smart fashionable ensemble. For instance, a dog can be brought with you for a stylish statement when shopping. There are two important aspects to ponder when being a fashionista à la pooch. How to snazz up the dog's appearance is one. For instance, giving the dog a purse look. The other aspect is the size of the dog, i.e., big dogs overpower your own fashion statement unless given a long leash.

A flower in any dog-based ensemble is an added flourish. However, flower motifs work best with that pint-size dog. Bold geometry works best with large wolf-hound types. Remember Saint Bernards overpower any fashion setting.

8. Candy Wear (p. 153)

Fashion to me is like candy, the kind of candy that you bought when you went to the store when you were a little kid. You buy this sweet stuff and put it in your mouth, and it hits you, Kapowie! Five minutes later it's gone. But it was fun, and you want to do it again. This is how I see fashion jewelry, at least the kind of fashion jewelry I am interested in. There's no depth to it—this thing is not talking to you about something important. The idea is that—Wow this thing hits you somewhere between wonderful and stunning and then it disappears.

A memory of a fun experience is all that is left in time. But with jewelry you can always put it on again.